TAKE GREAT PICTURES
A SIMPLE GUIDE

Lou Jacobs Jr.

AMHERST MEDIA, INC. ■ BUFFALO, NY

All photographs by the author unless otherwise noted.

Published by:
Amherst Media, Inc.
P.O. Box 586
Buffalo, N.Y. 14226
Fax: 716-874-4508
www.AmherstMedia.com

Publisher: Craig Alesse
Senior Editor/Production Manager: Michelle Perkins
Assistant Editor: Barbara A. Lynch-Johnt

ISBN: 1-58428-102-2
Library of Congress Card Catalog Number: 2002113011

Printed in Korea.
10 9 8 7 6 5 4 3 2 1

Notice of Disclaimer: The information contained in this book is based on the author's experience and opinions. The author and publisher will not be held liable for the use or misuse of the information in this book.

table of contents

introduction

● WHY WE TAKE PICTURES

Why do we take pictures? While I don't know you personally, I do know the reasons why most people take pictures. Your incentives to enjoy photography are probably on this list:

1. To record the activities of yourself, your friends and family. Everybody (except the occasional Scrooge) likes to shoot—or at least see—pictures of new babies, family and friends at leisure or playing, celebrations, and scenic destinations.

2. Another prime reason to take pictures is to frame and hang your best shots. Which reminds me, do you keep your prints in orderly albums? My wife is our album archivist, and she gives each print a roll and frame number on the back, plus a date. We can easily find negatives to make reprints. Assembling albums takes more time than storing pictures in drawers and shoe boxes, but the effort is absolutely worthwhile— especially when you show them off.

3. Photography is a fulfilling hobby. On vacation few people travel without a camera, and they are often rewarded with images of beautiful scenes, details of nature, cityscapes, seascapes, etc. For photo enthusiasts, getting there can be at least half the fun. I jokingly say if the weather was nasty on a trip and I couldn't shoot many worthwhile pictures, I wasn't there.

4. Showing your pictures can be a kick—maybe at a camera club where you can win awards. Discussions about picture-taking stimulate us to find good subjects around home, at the zoo, at county fairs, etc. Then it's fun to get encouraging feedback from others.

For photo enthusiasts, getting there can be at least half the fun.

5. Having saleable pictures is a further incentive. You don't have to be a professional to make saleable pictures (although you might not know how and where to sell them yet). When your pictures are good enough, sales to friends and relatives can get you started.

⊙ WHAT'S AHEAD?

I've been a professional photographer for a long time, and many pictures in this book are mine, but some were taken by other professionals and skilled amateurs. Each subject and technique is presented to stimulate your creative urge to shoot your own versions of the subjects you choose. Composition, lighting, people, activities, and photos of photogenic places are yours to emulate. Don't worry about being a copycat. Every successful photographer has been inspired by role models. Famous painters were, too—in his early years, Van Gogh did well-known copies of artist Millet's work. Admiring quality photographs is a neat way to be "under the influence." When you are feeling enthusiastic about your photography, you can move on to read more about the subjects that particularly interest you in other books. But now, read on and get involved.

What sort of plant is it? Maybe it's two plants, one with flowers? Why do the long green leaves appear transparent in some places? Actually, it's a double exposure. My SLR was set for two exposures on the same frame of film, and I doubled the film speed to ISO 200 so the combined images would equal a single exposure. There's more about this technique in chapter 10.

1. what makes a great picture?

When I searched for photographs to illustrate this book, many were rejected because they were not good enough. They were mundane or technically flawed. Exploring hundreds of slides and prints made me think: what are the main qualities of great pictures? In the following paragraphs I've tried to answer that question. Interpret your own pictures using the same criteria. Discuss these topics with friends for enlightening differences of opinion. Here's what most people look for:

Strong Composition. The picture should have a main subject that's usually in a prominent area. A main or dominant subject catches your eye first. It may be an individual, an exciting moment in sports, poignant children, dramatic buildings or mountains, etc. In a portrait, the facial expression is usually dominant. In a landscape the dominant element may be a range of mountains or a field of flowers or a line of breaking waves. In a good composition, the background should support the main subject. Try to keep it simple and uncluttered. Composition is covered in greater detail in chapter 4.

Emotional Impact. You encounter this quality in human-interest and story-telling situations. Many newspaper and magazine pictures include emotions caught on film, such as hopelessness in refugees or the excitement of winning a race. When you don't want to invade someone's privacy at a critical time such as an accident, keep your distance and consider using a telephoto lens (roughly 100mm or longer) to get emotionally rewarding pictures. Human contacts that occur anywhere may be dramatic,

> What are the
> main qualities
> of great pictures?

fascinating, and believable. Photography of people under stress or celebrating is often journalistic, but you don't have to

An example of strong composition by Richard W. Tolbert. He planted his tripod on a wide divider in the center of Chicago's Michigan Avenue, checked exposure with a handheld meter, and exposed 100 ISO slide film for twelve seconds at f/11. He anticipated white headlight lines and red lines of tail lights as decorative elements. The composition is appealing and dramatic.

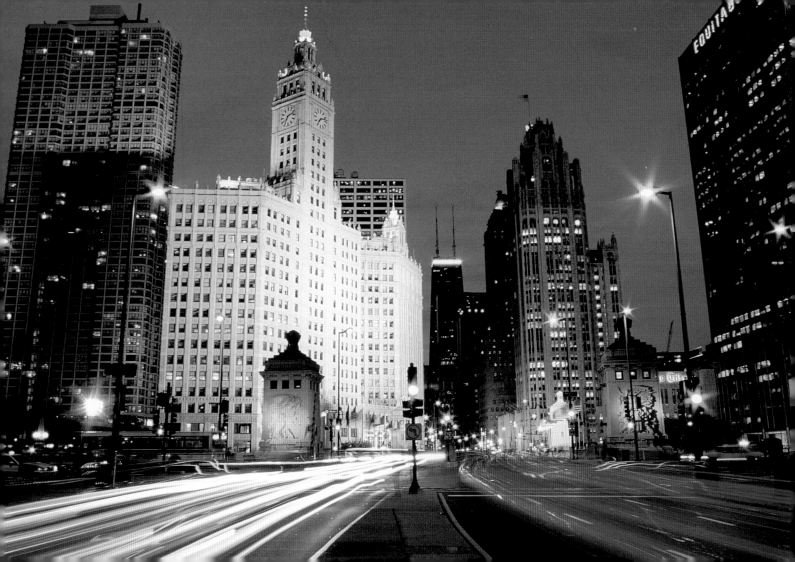

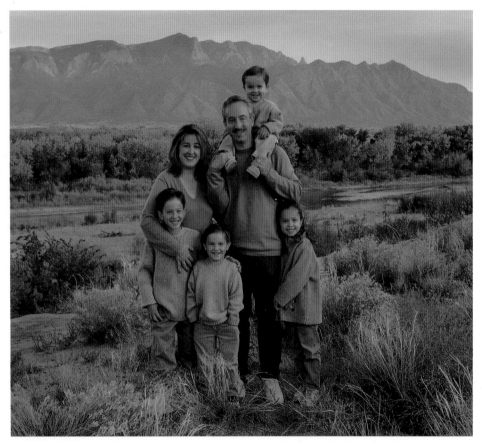

Frank Frost made this beautiful, painterly photograph of a family just after the sun went down at a favorite location outside of Albuquerque, NM. Frank is a veteran professional portrait photographer who has created a style based on use of subtle color, soft light, and an enviable ability to put his subjects at ease. Capturing happy, sad, and animated expressions on film can help you to intrigue viewers and enhance your reputation. Frank's specialty is family portraits; he used a medium format camera and color negative film to capture this image.

work for a newspaper to photograph the moments you discover.

Lighting. The lighting in a memorable composition is often beautiful, or at least shows off the subjects and helps tell the story. In the photo on the facing page (left), a visitor tries to keep her feet dry during a hike in Colorado. The use of backlighting adds pictorial punch. Bright water and the dominant, shadowed woman give the image impact. Outdoors, look for dramatic or soft

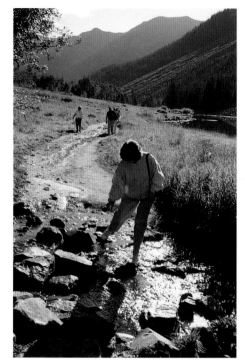

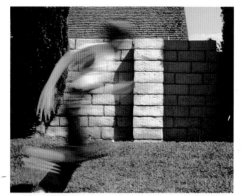

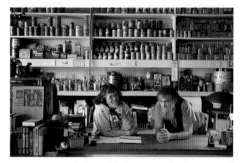

Action. Most sharp action photos are taken with fast shutter speeds, but the one here (top right) shows action by using a blurred figure. I used a slow shutter speed ($\frac{1}{2}$ second) with a single-lens reflex (SLR) camera on a tripod so the background would be sharp. Good action opportunities occur with children at play, weddings, animated parties, sporting events, and recreational games. You need to catch exciting movement or intense facial expressions, so encourage people to do active things for pictures.

Realism. The term "documentary" usually indicates a realistic situation. Shot in a refurbished general store in Jacksonville, OR, this is an authentic setting lit by a window to the left (this page, bottom right). The couple was asked to pose, and I braced myself against an opposite wall to shoot at $\frac{1}{2}$ second on ISO 100 Ektachrome film using a Canon 28–135mm IS zoom (the

lighting to enhance a subject. Contrasty lighting has a strong look with noticeable dark shadows, and it works for subjects like tough guys, rugged mountains, or street parades. Light reveals shape and helps create mood, often forming detailed highlights and shadows. I rhapsodize again about light in chapter 5.

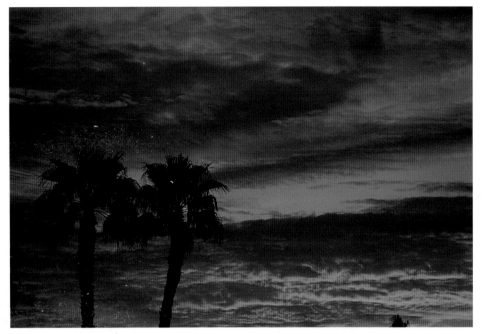

attention. Sunrises (left) are photogenic, but they may not win contests because judges see so many of them.

● PICTORIAL SEMANTICS

There is a difference between a photograph and a snapshot. The word "snapshot" refers to a quickly taken photographic image that is rarely a great picture. Snapshots are valuable because they show moments in our lives that we want to remember, but they are not expected to have artistic or pictorial qualities.

Pictures taken with some serious consideration of composition, light, nature details, etc.—especially when you use a tripod—are more likely to be more pictorial photographs. It's semantics, I admit, but I rarely use the words "photo" or "snapshot." We all take snapshots, and we should also be aware when we're taking this casual approach.

"IS" stands for image stabilization, which allows me to handhold the camera at slow shutter speeds).

Visual Impact. This term describes the "pizzazz" in memorable pictures. It can be created by an appealing composition, emotional people, color, light, and sometimes by offbeat subjects. Any number of pictorial conditions can team up to achieve visual impact that grabs

Take snapshots in your leisure, but try serious photography, too. I believe you know the difference.

Greatness. Calling pictures "great" can seem exaggerated and even embarrassing. In *Webster's Universal College Dictionary* there are twenty-one definitions of "great." Those I'm comfortable with to describe photographs include "excellent," "first-rate," "notable," "significant," and "distinguished." If you are uneasy about trying to apply any of those words to your pictures because of modesty or uncertainty, try them one at a time. Decide which of your pictures are "above average" to start. As you become more confident in your ability to create and judge pictorial quality, you can start

Red poinsettia leaves become the frame around yellow seed pods. The challenge was to create a simple close-up composition. I used an SLR and a 28–80mm zoom lens on a tripod, and stopped down to f/11.

to use the word "great" (or one of its synonyms) when you're really pleased. If someone disagrees, don't protest.

This very appealing photograph was part of a Christmas card sent by Rob and Melissa Dennis. It's an outstanding example of eliminating all but the essentials. Melissa took the picture with her point & shoot camera, and Rob helped arrange a black fabric background that absorbed shadows from the in-camera flash quite artfully. Both parents cajoled their models.

Politely ask why "great" is unsuitable and start a dialogue.

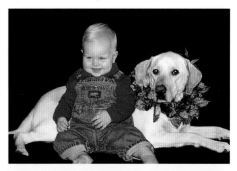

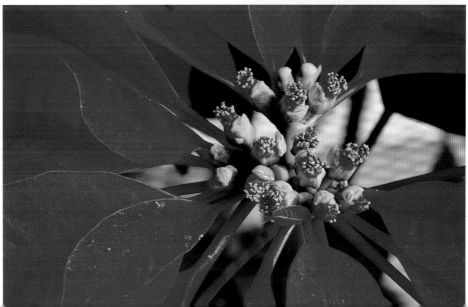

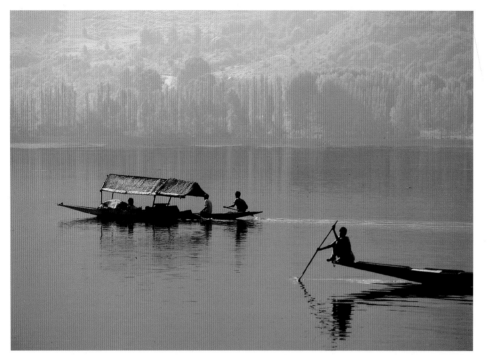

Lydia Heston made this atmospheric image in India, on Lake Dal at dawn. She describes it: "The romantic early light finds two Kashmiri fishing boats already on the scene." Not only is the photograph beautiful, but its story is told instantly. More of Lydia's fine pictures help illustrate other chapters, including a fascinating shot of her husband, Charlton Heston, in chapter 11.

● FINDING INSPIRATION

Photography is a wonderful adventure. Great pictures are your discoveries. The following tips may provide you with some inspiration for seeking out subjects of interest.

1. Save the photographs you really like from newspapers and magazines, and collect them in a visual idea file to stimulate your imagination. Think about shooting or creating situations similar to the ones you admire. If you get stuck for something to photograph, you'll have an inspiring collection.
2. If photos are allowed, try shooting at concerts or wherever there are lots of colored lights.
3. Photograph birds flying by following them with a camera. Choose simple backgrounds (the sky is perfect).

4. At dusk or at night, stand on a bridge with a tripod and shoot down on car traffic. Vary your exposures to get different light streak patterns.

5. Set up rows of small objects in amusing patterns or geometric rows and light them from one side. Outdoors, low sun will do it. Get close with a close-focusing or macro lens on an SLR camera. Use a reflector. Consider other subjects for great still life subjects, too.

6. Photograph a dog, cat, lizard, or other pet. Stay close and try to eliminate background clutter. Shoot some action pictures of them with children, and some poses too.

keeping orderly prints and negatives

Can you find negatives or prints made in the past? It's worthwhile to file them with a system you'll be glad you started. Here are suggestions.

1. Number each roll of developed film, and list it in an index like a small spiral-bound notebook. With the roll numbers, list a few identifying words such as "Family on Picnic at Big Rock Park."
2. Date the top of each index page. For day-to-day rolls that aren't of a particular event or place, date each entry to make finding pictures easier. Use regular mailing envelopes to store negatives and a separate envelope for prints so negatives don't get scratched. Rubber band the envelopes for each roll together for storage.
3. Number each print (or slide) with its roll and frame number. Use a Sharpie pen that writes on photographic printing paper. *Throw away prints or slides that are useless.*

This may sound like a lot of trouble, but if one of your pictures wins a prize, is selected for an exhibition, or a friend wants to buy an enlargement, you'll find numbered and indexed negatives in two minutes or less.

2. *basic technical terms*

Today's automatic cameras are easier to use than the average computer, because there are fewer things to remember. Using compact (point & shoot) cameras is almost effortless, and even single-lens reflex (SLR) cameras can be set to make most shooting decisions. However, to become a better photographer and, now or later, select shutter speeds and lens openings yourself, you should know how they relate to exposure, subject movement and depth of field. Awareness about composition, timing, and pictorial light are equally important.

○ EXPOSURE

F-stops. The amount of light passing through a lens is regulated by a series of openings called f-stops or aperture numbers. F-stops are not indicated on most digital or film point & shoot cameras or lenses, but they are inscribed on the lens mount or displayed in the finder of SLR cameras.

The main f-stops are f/2, f/2.8, f/4, f/5.6, f/8, f/11, f/16 and f/22. The smaller the f-stop number, the larger the aperture, so f/4 allows more light (twice as much) to enter the camera than f/5.6, etc. Memorize the numbers if you wish, but primarily understand that from one number to another, exposure is either increased or decreased.

Since automatic exposure is the main mode on most point & shoot, SLR, and digital cameras (though manual exposure is an option on SLR cameras), not

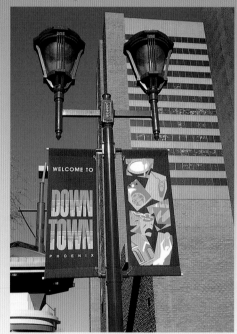

I composed this shot in Phoenix, AZ, to illustrate the city's promotional signs. A 28–135mm lens was focused on the lamp post. I checked the depth of field preview (see page 23) with the aperture at f/11, and the whole scene was sharp.

knowing the exact f-stops or shutter speeds a camera chooses is usually not a drawback. When you feel the need for more exposure and focusing control, a more versatile SLR camera may be the answer.

Shutter Speeds. Camera shutters expose film or small digital disks in fractions of a second. In 35mm point & shoot film and digital cameras, shutter speeds are chosen by the exposure system. Though you can't alter point & shoot shutter speeds manually, in most situations you can trust the camera to make correct settings for the light, subject matter, and the film speed. SLRs (film and digital) enable you to adjust f-stops and shutter speeds for added creative options.

The faster the shutter speed, the more likely that action will be sharp on film. Many single-lens reflex cameras include shutter speeds of $1/2000$ second

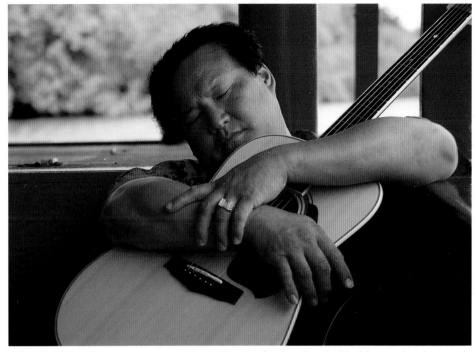

When the guitar player on a river tour boat in Kauai took a short break, I liked the mood and composition and shot at $1/60$ second at f/4.5 with a 28–105mm lens on an SLR. Using ISO 100 film, I held the camera steady and the subject was still. The zoom was set at about 100mm and the background is nicely out of focus. Practice handholding your camera at speeds such as $1/15$, $1/30$, $1/60$ and $1/125$ second. Compare the prints.

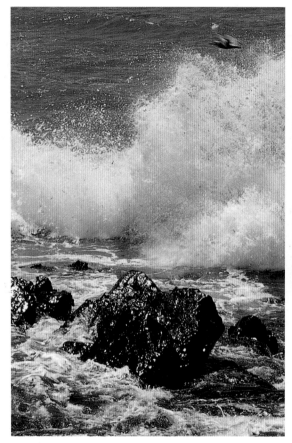

ABOVE—Because this scene in Venice, Italy, had a full range of tones from bright to dark, my SLR camera meter provided a perfect exposure. **LEFT**—This glimpse of the California seashore was photographed at $\frac{1}{250}$ second on ISO 100 film with a 35mm camera and zoom lens set at 150mm. A faster speed would have sharpened the bird, but the slight blur increases the feeling of action, and the overall focus is good.

RIGHT—Zebras at an animal park seemed to be doing a dance, which my SLR caught at $\frac{1}{250}$ second. A 70–200mm zoom was set at 200mm and the meter indicated f/5.6, which put the background into soft focus. The slide film was rated ISO 100, and with ISO 200 film I could have exposed at $\frac{1}{500}$ second.

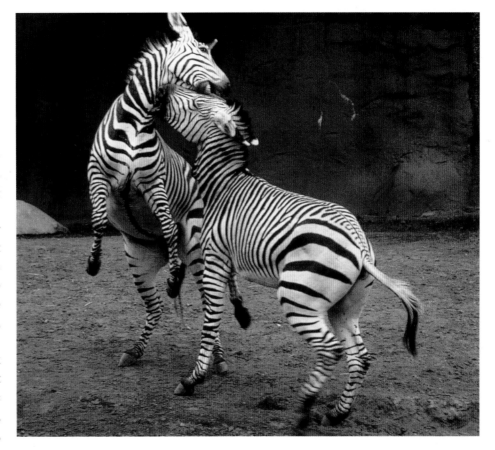

and faster. Fractions in the thousands may sound cool, but the top speed on my SLR cameras is $\frac{1}{4000}$ second and I rarely need it. A $\frac{1}{500}$ second or $\frac{1}{1000}$ second exposure can be very effective for many sports situations. Just as important for low light or night photography are slow shutter speeds from one second to thirty seconds. Digital cameras may also offer a versatile range of shutter speeds, depending on the brand and model.

Familiarize yourself with a point & shoot camera's slowest and fastest speeds, which should be given in the instruction booklet. With all cameras, when shooting at $\frac{1}{30}$ second and slower,

a tripod is recommended to guarantee sharp pictures. If no tripod is available, brace your camera against a pole or on a chair or table. There is more on this in chapter 3.

Light Meters. Light meters average the bright and dark areas of a subject and set an exposure to match the film speed in use. The exposure meters built into automatic 35mm film and digital cameras are amazingly accurate. You can rely on your meter when using color negative films, but you may use exposure compensation with slide films that require more exact exposure. As an example, with slide films you should add more exposure for a bright snow scene, and subtract exposure for a predominantly dark scene. Exposure with a digital camera can be previewed on its LCD (Liquid Crystal Display) monitor. (See chapter 5 for more about exposure.)

● LENS

Focal Length. Expressed in millimeters, the focal length describes how lenses "see" what we photograph. Zoom lenses are a versatile choice because they allow you to use a range of different focal lengths without switching lenses. For 35mm film cameras short (wide-angle) focal length zooms range from less than 21mm to about 40mm. Medium focal-length zooms range from 50mm to about 105mm, and long (telephoto) focal length zooms range from 120mm to 500mm and longer.

● DEPTH OF FIELD

Depth of field is the area of *acceptably sharp focus* between the nearest and farthest subjects in a photo. Four factors regulate depth of field: focusing distance, lens opening, focal length and film speed. The depth-of-field numbers in my examples are only approximate.

Focusing Distance. The farther away you focus and the brighter the light, the more depth of field you can expect. As you focus closer, depth of field decreases at a given f-stop. Depth of field extends a greater distance beyond the point of focus than it does in front of it. For example, if you shoot a subject twenty feet away in bright sun, the zone of sharp focus may begin at seventeen feet and can extend to fifty feet or more, depending on the lens and f-stop. If you focus two feet away for a close-up, the zone of sharp focus may only extend from 22" to 28", depending on the f-stop used.

Lens Opening. The smaller the lens opening, the greater the depth of field. When you shoot a portrait and focus 3' away, you could set the f-stop at f/5.6

FACING PAGE—Rocks on the shore of Oregon's Pistol River State Park became an ideal perch from which to photograph surf sailors.

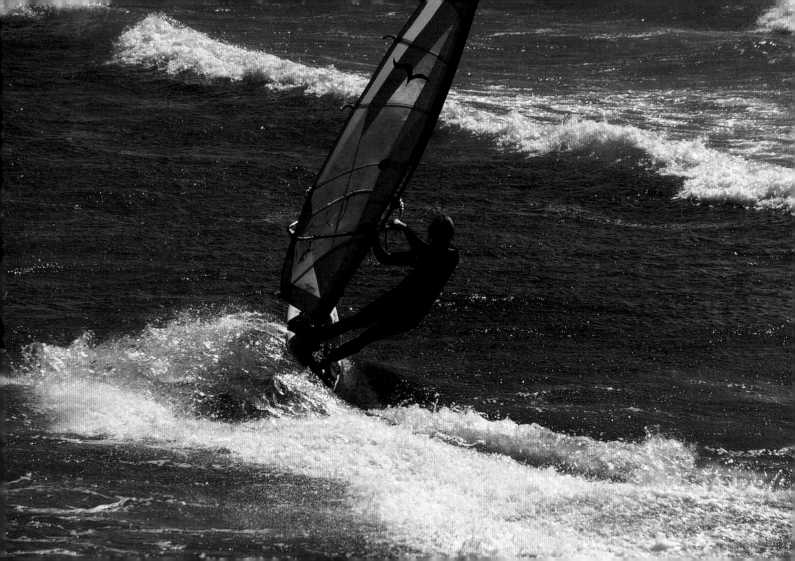

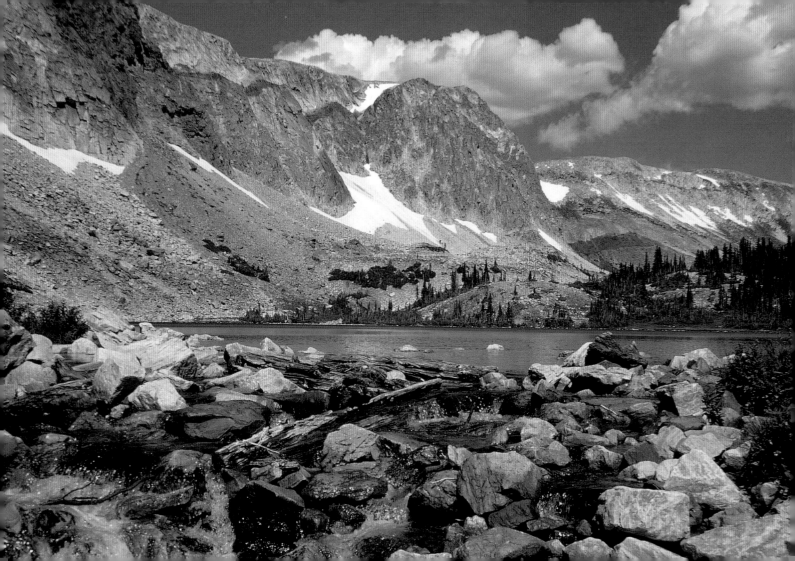

for an out-of-focus background or at f/11 or f/16 to keep the background sharp. When shooting close-ups, select such smaller apertures as f/16 for sharp focus from the foreground to the back of the image.

Lens Focal Length. At a given aperture and focusing distance, lenses with longer focal lengths create less depth of field than lenses with shorter focal lengths at the same f-stop used closer to the subject. Shoot comparison pictures with an SLR and several different

FACING PAGE—Depth of field, sharp focus from the foreground to the clouds, was important to this Wyoming landscape. The camera was on a tripod and the zoom lens was set to 28mm. Using 100VS Ektachrome, the f-stop was f/22 and the shutter speed was ⅟₁₅ second to slightly blur the flowing water. I focused on the top of the foreground stones and checked depth of field in the SLR finder. Depth of field can be improved by using a faster film, a smaller f-stop, a slower shutter speed, or all three.

lens focal lengths to see the effect for yourself.

Film Speed. The higher the film speed the greater the depth of field at a given f-stop, focal length, and focusing distance. You get more depth of field in general using an ISO 200 film rather than an ISO 100 film. I recommend using ISO 200 films in point & shoot cameras to assure smaller f-stops and higher shutter speeds. When professionals shoot ISO 100 or slower slide films, they may do so for the fine grain and good color saturation.

● PHOTO EXERCISES

For depth of field practice, photograph a row of objects (or a picket fence, or a line of people) at a 45-degree angle to the camera. Use a tripod, focus on the closest person or object, and shoot at f/4, f/5.6, f/8, f/11, f/16, and f/22. To better see how the depth of field

increases as aperture decreases, don't change the focus. For later reference mark the specific f-stops on your prints.

Here's another depth of field exercise that's trickier. Suspend a necklace or a loop of rope in the foreground. Put your camera on a tripod, frame closely, and focus on the necklace or rope. Ask someone to pose behind the loop with his or her whole face showing. Shoot at a series of f-stops. If your SLR features a depth of field preview, use it as an aid. For a variation, focus on the person's face. Keep a record of the f-stops you use, so you'll know which ones held both the loop and the face in focus. For these exercises, a zoom lens makes it easier to test at several focal lengths. You will find out how your lenses control picture sharpness.

3. cameras, lenses, films, and filters

This chapter offers basic guidance about the equipment photographers use. Additional information on specific brands and models can be found in photo magazine ads, product reports and feature stories. You can also check manufacturers' web sites and request their literature, as well as discuss equipment and films with people whose experience and judgment you trust.

○ FILM CAMERAS

Point & Shoot 35mm Cameras. These are very popular cameras with dozens of makes and models to choose from. In general, the more expensive the camera, the more features it will offer, and the greater its zoom lens range will be. Built-in flash, automatic exposure, focus, winding, and rewinding are stan-

My brother, Martin Jacobs, took this view of Sydney, Australia, from a hotel window that didn't open. To solve the problem, he pressed his Pentax point & shoot camera against the glass at an angle to avoid reflections. He framed a view of the city with buildings on each side and captured early-morning pastel colors as well as reflections at the right. Marty used ISO 200 negative film.

dard on these cameras. Point & shoot cameras are lightweight and versatile, but they lack the exposure and focus controls of SLR cameras. For close-up work, a point & shoot finder doesn't let you see exactly what the lens sees, but you learn to compose and to crop if necessary. To make camera comparisons, helpful charts are published in end-of-year issues of *Popular Photography*.

Single Lens Reflex Cameras (SLR). These are the choice of professional photographers and enthusiastic amateurs. SLRs include automatic and/or manual exposure and focus, built-in flash and precise finders. With the manual controls, you can choose your own shutter speeds, lens openings and focal points. You can also choose between lenses of many focal lengths.

More expensive SLRs (usually over $500 for the body) offer features the average photographer doesn't need—and the more the cost, the heavier the camera tends to be. It takes research to pick the best SLR for you from the dozens available, but there are many brands and models that can help you be more versatile and creative.

Rangefinder Cameras (RF). This type of 35mm camera has a viewfinder that is separate from the lens and works fine, but it's not as satisfying as composing and focusing through the lens, as

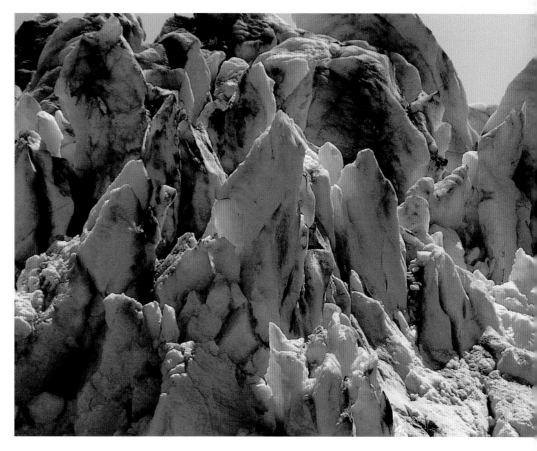

Using her Canon Rebel 2000 SLR, Margaret LeBoutiller photographed a detail of Lamplugh Glacier in Alaska from a ship using a 28—200mm zoom. Margaret likes ISO 200 print film, but realizes that other films could have done as well to show jagged ice formations on the glacier, which moves imperceptibly. The rugged pattern composition is organized beautifully.

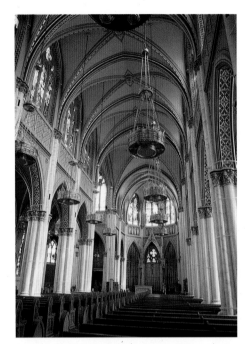

I used a 21–35mm zoom lens on an SLR to photograph the Cathedral of St. Helena in Montana. There was good daylight and I braced my handheld SLR against a pillar to expose ISO 200 Ektachrome slide film.

you do with an SLR. Fewer lenses are made for RF cameras, and most are in higher price brackets. Pros like RF cameras for their quiet shutters, though I feel there's a mystique about them that attracts some shooters.

Medium Format Cameras. This category includes cameras that use 120-size films that make $2\frac{1}{4}"\text{x}2\frac{1}{4}"$ or 6x7cm negatives/transparencies. Most are SLR models, and they can weigh three pounds or more. These models are popular with wedding, portrait, and nature photographers who want larger negatives and transparencies. There are fewer brands and models of medium format cameras than there are of 35mm SLRs, and their bodies and lenses are much more expensive than a majority of 35mm SLR bodies and lenses.

View Cameras. The 4"x5" and larger negatives/transparencies created by view cameras are favored by architectural and interior photographers, who also appreciate the larger finder image and the fact that vertical lines can be kept perfectly vertical by manipulating the camera back. Some serious fine art and studio photographers are partial to view cameras because of their precise finders and large negatives.

● DIGITAL CAMERAS

Digital models are the camera of choice for a growing number of photographers who want to see what they've taken instantly. If the subject hasn't departed, this allows you to take more pictures to improve poses, composition, or lighting. Digital enthusiasts also appreciate the ability to transfer their images to a computer where improvements and manipulations are possible. Alternately, a computer can be bypassed by inserting the camera disk directly into a printer. Good digital prints have sharpness and color

qualities equal to prints from negatives or slides.

Digital cameras are rated in megapixels—the higher the number, the greater the image resolution. Point & shoot digital cameras have excellent zoom lenses, and SLR digitals from Canon, Nikon, and Minolta use film-camera lenses, making them favorites of professionals. A good starting point is with a mid-range camera ($200–$500) from which very nice enlarged prints can be made. Professional photographers who shoot for newspapers and magazines with fast deadlines use top-quality digital cameras (in the $2000–$7000 range). Using a laptop computer, they can immediately transmit images via the Internet to their publishers while an event is still underway.

If you don't have a digital camera it's also possible to scan color prints, negatives, or slides into a computer and do whatever you wish to improve the images before printing them as you would images from a digital camera.

⦿ ZOOM LENSES

Popular Photography's annual list of interchangeable zoom lenses covers many brands and focal length ranges. Camera manufacturers make lenses to fit their SLR cameras, as do other independent companies. Whether lenses made by your camera company are better than those from independent firms is a matter of opinion. I've used both, and I tend to choose independent brands for their lower prices.

At an outdoor art show I came upon this lively group of visitors who had been posing for a photo taken by the man on the right. I asked him to join them and to hold this pose, which created a nice juxtaposition between the people and the huge sculpture. The camera was an SLR loaded with ISO 100 slide film, and I used a 28–105mm zoom lens.

Newer compact zoom lenses weigh less than older models and may be worth your investment. Because the sharpness on modern zoom lenses is generally excellent, you may only need fixed (sin-

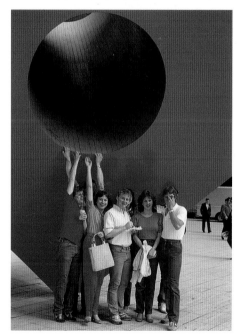

gle) focal-length lenses for special applications, such as extreme close-ups. I find the following zoom ranges to be the most useful: 21–35mm, 28–80mm, 28–90mm, 28–105mm, 28–135mm, and 70–200mm or 75–300mm. Also handy are 28–200mm and 28–300mm zooms. One zoom lens can replace many fixed focal-length lenses and help minimize the weight of the equipment you need to carry.

● FILM CHOICES

Of the many different films from Kodak, Fuji, Konica, Agfa, Ilford, and others, only a few are needed by the average photographer.

Color Negative Films. Also called color print films, color negative films are very versatile. They are balanced for day-

light, but most of the color shift from shooting indoors with artificial light can be color-corrected in printing. Small

exposure errors can also be corrected when negatives are printed, as noted in chapter 5. Brand to brand, the differ-

This family portrait was taken on an SLR with a 28–80mm zoom lens and Fuji color negative film.

ences between color negative films are very slight. The following are some guidelines for selecting the right film speed.

1. ISO 100 films make lovely prints, but may be too slow for general use.
2. ISO 200 films are more practical for most photographers. They do well in bright sun or in shade and with flash. Prints enlarged up to 11"x14" compare well with those from ISO 100 films.
3. ISO 400 films are helpful in many situations where flash is not feasible (such as inside a church during a wedding), but you don't need ISO 400 in bright sun. Because ISO 400 films are more sensitive to light, your flash will be effective over greater distances than with slower films. With ISO 200 film,

flash might be effective to 13'–15', compared to perhaps 18'–20' with ISO 400 film.
4. ISO 800, 1600, and 3200 films are helpful for photography in relatively dim light without flash. Often you can handhold the camera and still get sharp pictures.

Color Slide or Transparency Films. The color differences between the best-sellers from Kodak, Fuji, and Agfa are a little more distinct with slide films than with negative films. Daylight slide films can be used in artificial light

This was taken on color slide film, which many magazines and stock picture agencies prefer. Slides are often digitized ("burned") onto a CD-ROM for viewing and delivery. Excellent prints can also be made from slides. In this close-up, my wife is feeding a Barbados sheep at the Oakland, CA zoo. The picture was taken on Ektachrome 100VS with a close-focusing zoom lens.

with a correction filter (80A) as explained in chapter 5. The following are some guidelines for selecting the right film speed.

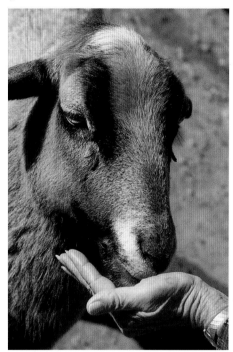

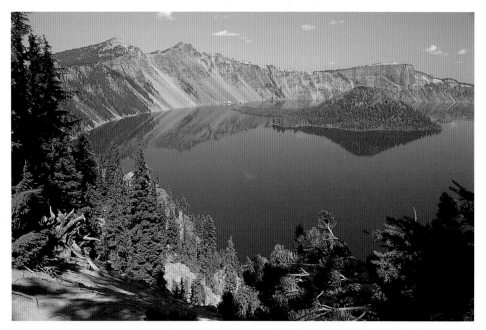
A 1A skylight filter was used to slightly warm a scene of Oregon's Crater Lake. A polarizing filter (which helps eliminate reflections) was not needed because I wanted to retain the reflections.

2. ISO 200 and 400 slide films are also made by the companies named above. ISO 200 is handy for general use, and ISO 400 is terrific for dimly lit subjects where flash isn't appropriate. Watch for slide film comparison charts or articles in photo magazines.

Black & White Films. These are made in all the popular ISO speeds. If you become interested in black & white photography, investigate film types and speeds in books and magazines, or seek advice from camera club members. Be warned that the mystique of black & white is contagious!

1. ISO 50 to 100 films offer the finest grain for enlargements beyond 11"x14". Fuji rates Velvia at ISO 50 but exposures are better at ISO 40. I like the speed and color qualities of Kodak Ektachrome 100VS.

● FILTER CHOICES

With color negative film, you rarely need a filter—which may explain why there's no way to attach one to a point & shoot camera lens. Some of the most com-

monly used filters for other cameras are detailed below.

Skylight Filter. A 1A skylight filter can be used to slightly warm a scene by faintly enhancing the warm tones (reds and yellows) and minimizing the cool tones (blues and greens). I keep one on all my lenses to protect them.

Polarizing Filter. A polarizing filter can be used to eliminate reflections and to darken blue skies.

Neutral Density Filter. A 2X neutral density filter can be used to cut the film speed in half in special exposure circumstances.

Blue Filter. An 80A blue filter can be used to tint daylight-balanced slide film for use with indoor lights or floodlights.

Ultraviolet (UV) Filter. A UV filter helps to protect your lens and cuts haze-producing ultraviolet rays at the beach or at high altitudes.

Special Effects Filters. There are dozens of special-effect filters available to add special effects to your images. The cost of these can add up and you may not use them as often as you think, so buy only what you can't do without—at least at first.

Filters can be useful in countless ways that go beyond the scope of this book. For information on using filters with slide films, you may wish to check the filter chart in my book *Photographer's Lighting Handbook* (Amherst Media).

something old, something new

If you have been meaning to try a different film brand, speed, or type, try one (or all) of these experiments.

1. Buy a roll of ISO 400, 800, or faster film and take pictures in dim light indoors, such as at a nursery school or office. Shoot handheld and tripod pictures of a city at dusk. Surprise yourself.
2. Arrange to exchange lenses with someone who uses your camera brand to experience new views. Make some shots you wouldn't or couldn't do with your own lenses. Stimulate your imagination.
3. Test a new-to-you filter. Buy or borrow it. Try a polarizer or an 80A filter to correct color from warm indoor light sources. Experiment with the 80B filter and print film—and be sure to inform the processor that the filter was used so they'll know better how to choose their printing filters.

4. composition

Photographic composition is the art of seeing. It's how you interpret or record promising subjects to produce harmonious, stimulating, or just functional images. We want our photographs to tell a story or reveal things about the subject, usually more than just the way it looks. Composing a photo is a personal design project intended to yield pictorial impact.

As image designers we organize subject matter in the camera finder and hope people will admire our prints or slides. Unfortunately, wishful thinking often persuades us to take useless pictures with pointless or boring compositions. Just as we don't choose food from a smorgasbord with our eyes closed, we should not shoot pictures without evaluating their compositions.

Luckily, enthusiasm and visual awareness can motivate us to take well designed and satisfying pictures. Experience also helps us to distinguish good subjects from dull ones and previsualize subjects as they might appear in our prints.

As you become a better photographer, validate yourself. Frame and hang some of your best pictures, and give them as gifts, too. Praise for

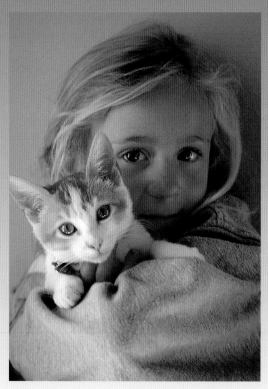

Pictures are often likeable because of their simple composition. I asked the child to hold her kitten in a diffused beam of sunlight. She wrapped her pet in the bottom of her sweatshirt, which further simplified the design. I might hove used a tripod to assure better depth of field but my models were impatient, and fortunately their eyes are in focus. This was taken with an SLR camera and a zoom lens on slide film.

your prints is encouraging. Also, analyze pictures wherever you see them. Visit museums and galleries, look through books, and learn how to tell a winner from a dud. As an incentive, contemplate being exhibited or published.

○ GUIDELINES FOR COMPOSITION

Rules for composition may be helpful, but following them overzealously can inhibit your urge to experiment. Here are some guidelines:

1. A good design is often built around a dominant subject. See "Elements of Composition," below.
2. The rule of thirds is a compositional formula based on an imaginary grid of lines (like a tic-tac-toe board) that divides a photo frame into nine equal sections. This formula says that when you place pictorial elements at the intersections of these lines, a composition will be more pleasing.
3. Avoid the temptation to center your subject, a common problem in photography and the cause of many static compositions. If you decide to center your subject, design the rest of the composition accordingly. This can be an effective composition to get attention.
4. When possible, find subjects that contrast with each other in their size, color, or shape. Viewers want to be intrigued as well as informed. Tall buildings contrasted with shorter ones make interesting subjects. Patterned vs. plain subjects can be appealing. Varying your camera angles can encourage variety.
5. Offbeat compositions often come from taking experimental chances.

For example, photograph someone in silhouette, or frame a building at a tilt. As a personal project, shoot conventional and unconventional compositions of the same subject. Some viewers may complain, but others will be intrigued.

Viewers want
to be intrigued
as well as informed.

6. Find someone whose taste you appreciate to critique your pictorial composition.

○ ELEMENTS OF COMPOSITION

Size and Position. The most prominent form (or array of forms) in an image is called dominant, and related subjects are secondary. To be dominant a subject might be larger; more signifi-

cant in shape, color, or emotional impact; nearer the center, or at a rakish angle. In a portrait, the person's eyes are often where you look first. Secondary subjects are less prominent, but pictorially important because they support the dominant element.

Balance. This topic often separates the traditionalists from the modernists. The former prefer pictures that are organized in an S-curve, or use a formula for subject placement. Many forms of traditional composition are worthy ways of seeing, and traditional variations are hung in most exhibitions of photography and other fine art. Off-beat balance may put a figure far to the right or left, or create an intentional jumble to attract attention. Make your own balance experiments, and discuss them with others who care about photographic composition. Join a camera club and share your opinions.

Tonal Contrasts and Colors. There are many ways to contrast colors: bright colors vs. subtle ones; warm colors (reds, yellows) vs. cool ones (blues and greens); dark colors vs. light ones, etc. These contrasts can be used to define and differentiate your dominant and secondary subjects.

Perspective. Two photographic situations where perspective forms the basis for the composition are railroad tracks receding into the distance and rows of buildings that appear smaller farther down the street. Perspective adds drama and appeals to viewers. In landscape or cityscape photographs, consider including a figure or two in the middle distance for human interest.

● THE POSITIVE POWER OF CROPPING

Cropping means to trim out extraneous material on one or more edges of a pic-

ture to improve the composition. To experiment with cropping, cut a set of L-shaped cropping tools (see page 36) from heavy white paper. Use them to mask the edges of prints, experimenting and adjusting as you like. Don't worry if the best composition turns out to be skinnier or more square than traditional prints; there's no need for your print to be conventional.

Some photographers work to carefully compose 35mm pictures so they don't have to be cropped. Photographs printed from uncropped 35mm negatives or slides can be effective for ex-

Richard Tolbert used his medium format camera on a tripod for a dramatic interpretation of California poppies. The composition benefits from a brightly colored flower pattern contrasted with the darker texture of grass. Richard used a polarizing filter to darken the sky. Had he not tilted the camera, the composition would have been less interesting.

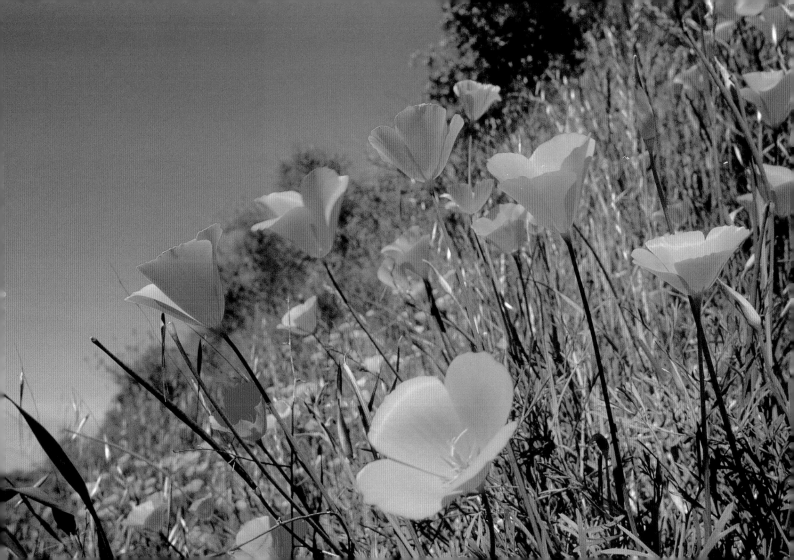

 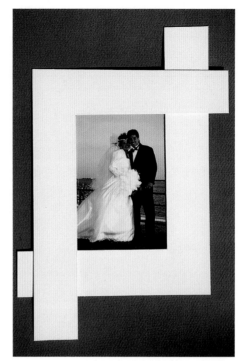

L-shaped cropping tools cut from heavy white paper were maneuvered to eliminate some of the image along its edges. On the left is the full image and on the right is a cropped and improved version. When the image is cropped as you want it use a sharp red marking pencil to make short crop marks as a guide for trimming or matting. If necessary, you can also have a larger print made to crop. Many images benefit by at least mild cropping.

pressing some subjects. Many famous photographers, like Edward Weston, Ansel Adams, Walker Evans, Alfred Stieglitz, and Eliot Porter, made exceptional images using the complete 4"x5" or 8"x10" rectangle. To take this careful approach, use a tripod, seek subjects that stay put, and compose slowly. Your decision as to whether or not to crop will be made based on your experience and tastes.

● COMPOSITION AND PERSONAL VISION

Content. Pictures are often memorable for their subject matter as well as their composition. Prime examples are news shots of people grieving or sport figures flying in midair. Photojournalists train themselves to see the essence of a situation instinctively so they don't miss decisive moments. While you're shooting, ask yourself what's important in the

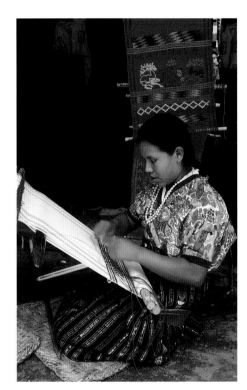
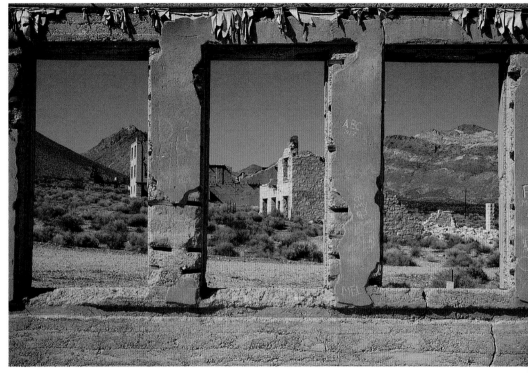

LEFT—During a visit to Guatemala, I was intrigued by a woman weaving with her work displayed in the background. I used a documentary approach by shooting quickly without asking her to pose (in a public setting, this is perfectly acceptable). The reflected light was just right for a handheld SLR exposure on slide film. **RIGHT**—The remains of a late 1800s building frames other architectural relics in Rhyolite, NV, a ghost town. I set my SLR camera on a tripod for a view through the wall openings, and positioned the finder edges parallel to the concrete structure. The composition is rather formal, even with the centered background building. Ruins are among my favorite photographic subjects because their damaged or rusted forms tell stories and always challenge my sense of design.

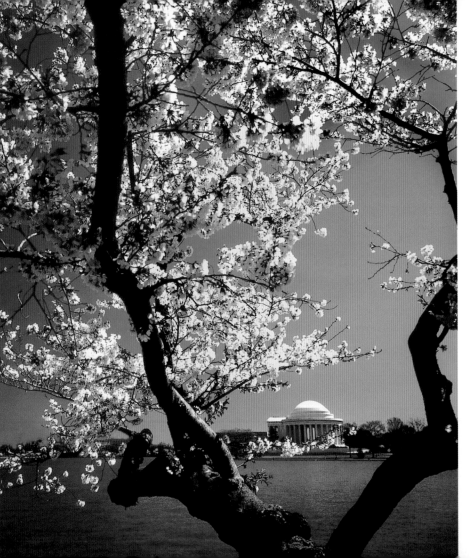

scene or subject, and explore ways to make a stronger composition.

Reality. Documentary photography often captures newsworthy moments, but you can also shoot situations and take time to find the best camera angles and light. Many photographs of landscapes, cityscapes, seascapes, and nature details may be composed in documentary style. Shooting with a tripod encourages good composition and image sharpness that emphasizes reality.

Framing. Framing a subject means shooting it surrounded or flanked by

Frank Peele explored around the Tidal Basin in Washington, DC, one spring day when the famous cherry blossoms were in bloom. Using a 35mm camera and Kodachrome film, he took his time to find the right tree to frame the Jefferson Memorial in the background. He then set his camera on a tripod for careful composition. The decorative cherry blossoms are memorable against the strong blue sky background. Frank titled the image *Mr. Jefferson's Bloomers*.

In this moody still life, Pat R. Murphy was influenced by his personal vision. Dominant is the still life on the table; the window and background are secondary. The table is well below center and the dark area visually supports the still life. Pat photographed this antique interior in an old cabin using a Nikon 8008 SLR and made several different exposures on color print film to be sure details would be clear.

some other compositional element. You can frame a scene by shooting from under a porch roof or through a window, for example. This is a useful compositional device that Frank Peele used to create a beautiful image of the Jefferson Memorial within a frame of stunning cherry blossoms.

Luck. Sometimes you see pictures that make you think the photographer got a lucky shot. In such cases, some people think that anyone could have taken the photo—but it's probably not true. What people call "luck" is actually what happens when opportunity and

preparation come together. You may shoot scenes that others miss because you had the opportunities and they didn't, and if you were aware of good composition, then you were also prepared. When you compose a shot well, that's not luck, it's experience at work.

Find a project that moves you to photograph over weeks or months.

Personal Vision. Many well-known photographers have a style you recognize when you've seen enough of their pictures. Personal vision, the way we see, stems from the unique convictions and sense of design that inspires each photographer. A prime example can be found in the work of W. Eugene Smith, whose marvelous and emotional compositions were often done quickly. His instincts were trained at *Life* magazine, and he is remembered as a unique photojournalist. (You can see his work in his book *Minamata* [Alskog/Holt Rinehart Winston, 1975].) In striking contrast, look for books by David Muench, whose elegant compositions of landscape and nature are outstanding.

Looking at Pictures. Look in picture books or images hung in exhibitions, and decide why certain compositions seem so successful. Many photographs can inspire you to emulate them. Also, study the content of unconventional images you may dislike. Be observant at movies, as well, because cinematographers are usually very skilled at composition. Write down your feelings and observations about pictures you see. Save and review the notes on rainy days.

Manipulations. If you are computer savvy, you can also adjust and enhance your images using software like Adobe® Photoshop®. Consult the manual that came with your software for instructions on using its digital cropping tool.

● A PERSONAL PROJECT

To test your compositional skills, find a project that moves you to photograph it over several weeks or months. A typical theme may be to follow a high school student through his or her final semester. Or, you could create a picture story about someone who works at a shelter for homeless people. You would need permission for either of these projects, but the photo opportunities would be excellent, and your personal way of seeing would improve because you'd be stimulated.

Other personal projects could involve examining your approach to landscapes, close-ups, or portraits. Consider a photographic study of an aspect of the town where you live. Try to make

order out of confusion in places that most photographers might ignore.

As a related personal project, study basic design. A book or a course in basic design can noticeably improve your photography. To experiment with design on your own, set up a series of still life pictures. Take your time choosing items of different sizes, colors, textures, and shapes. Then, place a 30"x40" sheet of colored paper on a table and run it up an adjoining wall. Arrange and rearrange items in your still life on this backdrop. Indoors, illuminate the scene using lights on stands, or move outdoors and use reflectors, sunlight, and/or shade. Explore the use of shadows. A tripod is a necessity for this exercise. If you have a digital camera, it can be very helpful, since it will allow you to view your images as you work.

Analyze your compositions. Are they too crowded? Is there variety in the way you positioned objects? Show your pictures to someone with art or design training, and ask for comments.

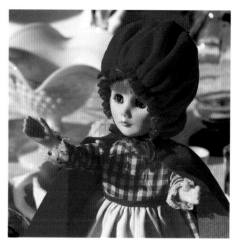

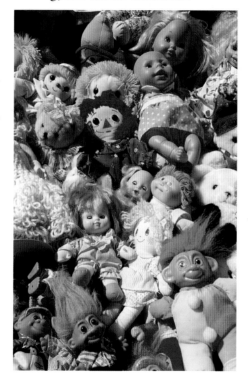

Two versions of dolls represent a subject one might make into a personal project about collecting or doll imagery. They were both photographed in displays at a street fair. I shot a vertical of the single doll, too, but the horizontal is a more intriguing composition. For the pattern of dolls the challenge was to create a composition with pictorial structure. Notice that from the bottom to the top-right corner there is continuous visual flow that helps the image.

5. *lighting*

Everything you photograph looks better in "good" light. For people pictures, light will ideally be reflected and soft. For lots of other subjects, bright sun can be just right. Some landscape scenes just aren't photogenic until clouds pass or rain stops. While rainy subjects can be pleasantly pastel, direct sun reflected or shining through thin clouds can be a photographer's best outdoor light.

○ LIGHT DIRECTION

Light can come from the front, side, back, or above a subject. Some examples are shown on the next six pages.

Front Light. Front light shines directly into someone's face, or straight at a building. The shadows formed by the light may not show much form. As a result, mountain and city scenes usually

look better in side lighting. However, in the photo on the facing page, front light does very well by the setting and the people.

Side Light. Light from one side or the other can be dramatic—but it may create a dark side with little detail. That doesn't matter in the photo to the right by Margaret LeBoutiller. Here, the low sun accents the boys and their raft against the water, and we don't mind dark shadows. Margaret used a Canon Rebel with a Tamron 28–200mm lens and print film. Side light also does a great job of showing form in landscapes and cityscapes.

Top Light. Top lighting is typical of summer sun and usually makes objectionable shadows under people's eyes, noses, and chins. These dark shadows can be brightened with flash fill. In the photograph shown on page 44, the top lighting was diffused by a translucent

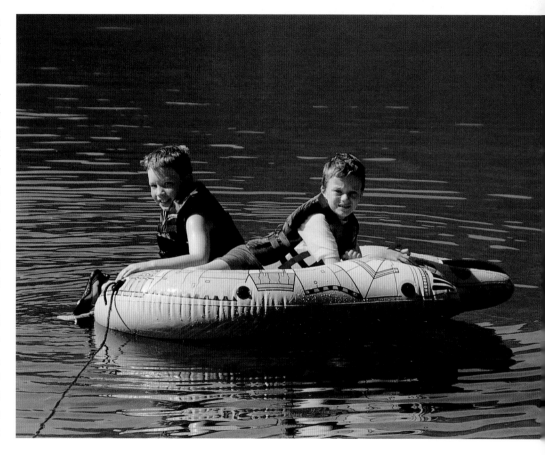

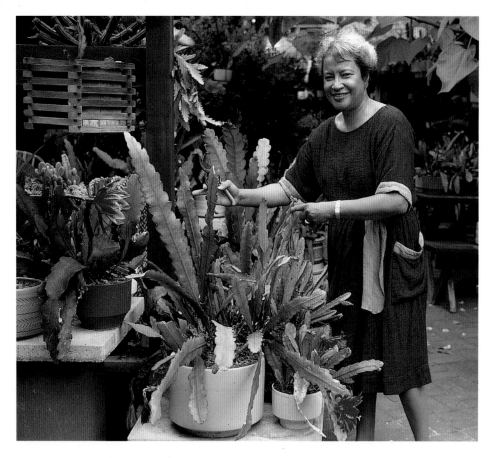

patio cover, so the shadows are soft on the lady and her garden. This is similar to the soft light created in photo studios with electronic flash and light modifiers called softboxes. When a setting like this isn't available, look for a shady spot for people pictures.

Back Light. Back lighting comes from sun or artificial light behind a subject, and it can be dramatic. However, faces and other subjects may be too dark, so use fill light from a flash or reflector to open up the shadows, or use the contrast as a pictorial element. In the picture on the facing page, light reflected from the wall at the right reduced the contrast of the back light shadow pattern.

● LIGHT QUALITY

People alone or in groups can appear beautiful in soft light from an overcast sky, or in reflected sun with only soft shadows on their faces. The image on

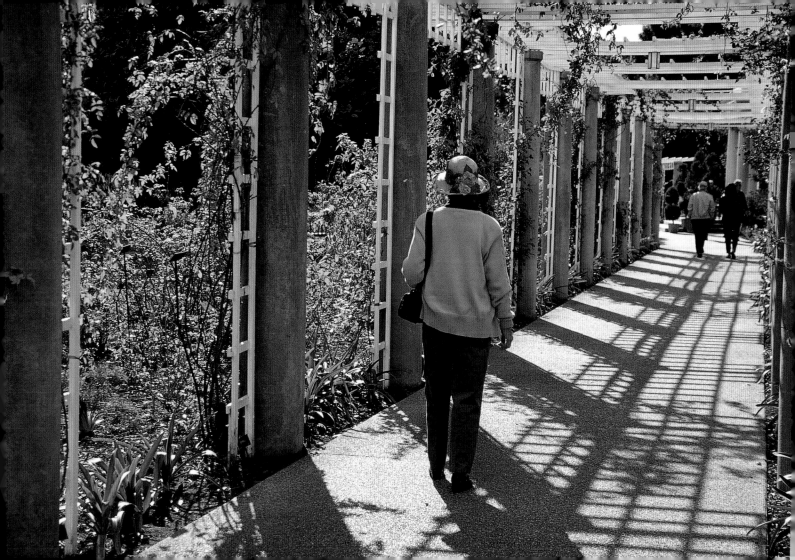

page 46 is an example of lovely shadowless light. It was taken by Margaret LeBoutiller in a cemetery adjoining St. James Church on the Isle of Wight, which is off the English coast.

When sun is absent, substitute with flash outdoors for brighter portraits or to boost light in the shade. Without flash, the image to the right would have had little sparkle because of the gray sky above. This image was created using direct flash on the camera. To soften the light from your flash, ask your local camera shop about flash diffusers.

● INDOOR LIGHT FROM FLASH

In-Camera Flash. Some cameras activate the flash automatically in low-light situations—indoors or out. It's also easy to turn the flash on manually. Study your camera's manual, and take note of the distance over which the flash is effective with various film speeds.

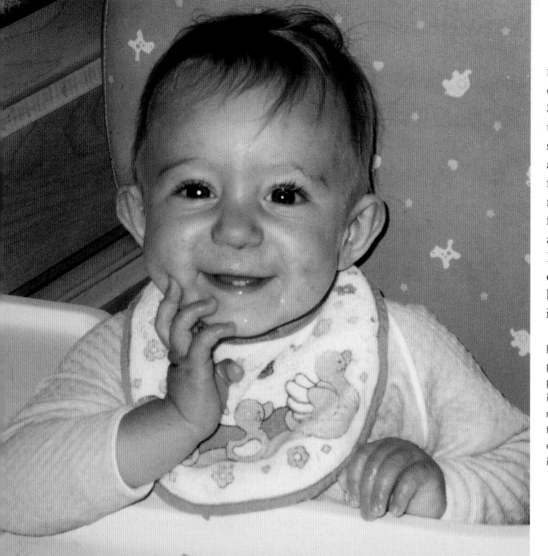

Add-On Flash Units. Both camera manufacturers and other independent companies make flash units for 35mm SLRs, certain digital models, and medium format cameras. A flash unit can be small and simple, or heavier, complex, and versatile. Through-the-lens (TTL) flash units, known as dedicated flash, may seem expensive, but they're worth it for their ability to combine flash and ambient light exposure automatically. Because these dedicated units use their own batteries, separate flash units also help your camera battery last longer; this is important for events, like weddings,

Kimberly was photographed with the flash in a point & shoot camera, the way most people snap pictures of kids, friends, and events. Having a flash in or on the camera is expedient. The camera makes all the exposure calculations, and the photographer needs only to compose the image and encourage a smile. Flash is also great for capturing action and spontaneous expressions.

where you may be shooting continuously for hours.

Multiple Flash. For smooth lighting, commercial photographers use multiple flash units from different directions. To do this, they employ flash units equipped with sensors called slave units that trigger additional off-camera flash units when the main flash pops. These slave units can be clamped to light stands, furniture, etc., and add light to eliminate annoying shadows created by the in- or on-camera flash. AC-powered studio flash units often have built-in slave sensors. A good way to get started working with multiple flash is to enlist the help of an assistant and use several flash units to create still life images or portraits.

Flash Modifiers. You can improve the light from a flash by using a modifier, such as an umbrella or softbox, to reflect the light off (or shine it through) a layer of fabric. In chapter 6, you'll see several portraits taken with reflected light from umbrellas. Some flash heads also swivel up, allowing you to soften light from the flash by reflecting it off a bright ceiling.

Flash Power. For the best lighting, you must know your camera's maximum flash range (check your camera's instruction manual). The light from a flash built into a camera is usually weaker than the light from a separate flash unit.

● THE COLOR OF LIGHT

The light spectrum runs from invisible ultraviolet through blue, red, yellow, and finally to invisible infrared. These varying types of light are differentiated by a value called their color temperature, which is measured in degrees Kelvin. The lower the number, the warmer (more red or yellow) the light is; the higher the number, the cooler (more blue) the light is. Sunny daylight is about 5600K, light from clouds is cooler at about 8000K, and the rust color of sunset or sunrise is warmer at about 3000K. Indoor lightbulbs are quite warm, averaging 2900K.

> You can improve
> the light from a flash
> by using a modifier.

Most color negative and slide films are rated at 5600K to match sunny daylight. If the light used to expose this film is of a different color temperature, you will see a color tint in the images. This can be corrected by shooting with a color correction filter. For example, on cloudy days (where the light is cooler than sunny daylight) slide shooters use a skylight 1A filter or warming filter (85C or Tiffin 812) to counter the bluish

light. Fluorescent lights create greenish tints, so use an FLD correction filter when you shoot daylight-balanced slide film in this light. A few slide films have a "T" (for tungsten) in their names; these are balanced to match the 3200K–3400K color temperature of photographic floodlight bulbs. More filter recommendations for balancing the film to your light source are noted below.

When using print film with artificial light, the color shifts that result can normally be corrected in processing the prints. When you use print films with tungsten lighting, for example, the print processor can try to correct the warm

In a temporary living-room "studio," this portrait was taken with hot quartz lights rated at 3200K. To balance those lights with daylight ISO 200 negative color film, I used an 80B filter. Its blue color helped to cool the light. My SLR camera was on a tripod far sharpness at the slow shutter speeds the filter requires.

tint on your subjects. Fluorescent lights create greenish tints, which, when print processors try to tame them, may create yellowish tints instead.

Because the color temperature of daylight changes throughout the day, some daylight scenes can also display color shifts. For example, snow scenes on a cloudy day or subjects shot an hour after sunset may appear with a blue tint in slides or prints (see the glacier photo on page 25). For slides and negatives, you can use a 1A, 85C, or Tiffin 812 filter to compensate—but do consider shooting some images without filters, as blue-violet evening scenes can be quite lovely.

● FILTERS

Most filters screw onto the front of 35mm and medium-format camera lenses and are sized in millimeters. Some filters are placed in a special holder in front

of the camera lens. If you are unsure what type or size of filters to use with your camera, take it and your lens to a local photo shop. Color correction filters are unnecessary for digital cameras, since color can be corrected with a computer program.

The following is a review of filters used mainly for slide films. When you use color correction filters with color negative film, be sure to note this on the film processing envelope. Otherwise, the processor may see your corrections as errors and try to compensate for them to eliminate their effects.

Skylight Filter 1A—Used to protect the lens and mildly warm subjects in shade or sun.

Polarizing Filter—Eliminates or reduces reflections from water, glass, metal, etc., and darkens blue skies. The filter is rotated while on the lens to view its effects.

80A Filter—Corrects the color of 3200K lights (flood-type or quartz) when used with daylight slide films. Works wonders when copying art indoors.

80B Filter—Very similar to 80A, but may be preferable for color negative films.

FLD Filter—Eliminates the greenish fluorescent tint in slides. Not necessary, but try it with color negative films.

⦾ THE LIGHT AT NIGHT

Night photography is a stimulating way to get pictures of brightly colored lights, mood and shadow effects, spotlighted fountains, and city skylines. Mount your camera on a tripod for night photography, since your exposures will typically be too long to safely handhold the camera. No filters are needed at night with either slide or print films. The following are a few tips and suggestions for interesting images:

1. Find out your camera's slowest shutter speeds by looking in your owner's manual. Some cameras are

> Your exposures will typically be too long to handhold the camera.

limited to a maximum shutter speed of a few seconds. Night exposures are usually in the six- to twelve-second range with 200 ISO films, so use ISO 400 and 800 films when slow shutter speeds are not possible. Many 35mm SLR cameras offer exposures up to thirty seconds, and some offer the option to use a cable release to

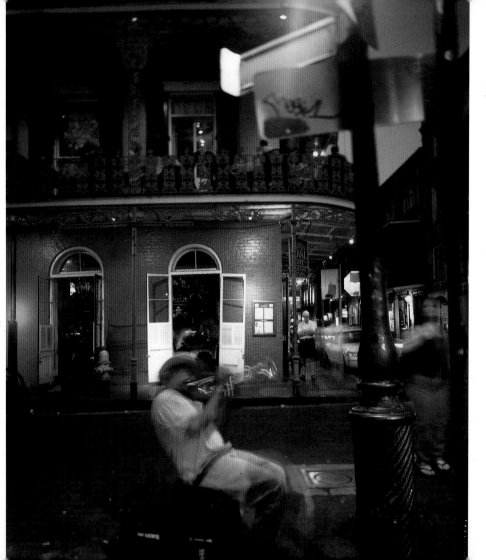

lock the shutter open for as long as you like.

2. There are dozens of tripods on the market, including some that weigh only three to five pounds. These are usually quite adequate and can be found at camera shops or in the electronics section of most major department stores. You can also add a ball head to the tripod, which allows you to easily rotate

Cheryl Himmelstein took this image during a *Modern Maturity* magazine assignment in New Orleans, a city she found especially exhilarating at late dusk when the street scenes were atmospheric. The magazine caption said, "Trumpeting to passers-by, a musician makes a glorious racket off Royal Street." With only a tint of blue left in the evening sky, Cheryl made this eight-second exposure with her favorite 4"x5" view camera using transparency film. "I enjoy almost-dark situations," she says. "Lights go warm on daylight film, and night makes every place look more glamorous."

the camera into just about any position.

3. For the fun of it, make a composition of outdoor lights and make

Take chances and discover how the familiar may look glamorous after dark.

zoom-during-exposure pictures with the camera on a tripod or handheld. On pages 56–57 there are two examples of images created using this technique.

4. Experiment, take chances, and discover how the familiar may look glamorous after dark. I once spent several nights shooting the grand night lighting displays on Las Vegas's main boulevard.

5. If there's sky in your pictures, begin shooting at dusk to get a wonderful blue behind the buildings (or whatever your main subjects are).

The more opportunities you make to take pictures, the more you learn about the pictorial qualities of light. There's an inspiring assortment of lighting effects available for your voyage of discovery in color and composition.

6. *portraits and groups*

○ PEOPLE PICTURES INDOORS

People are probably our most important subjects. In fact, it's not unusual for prints and slides to outlast the people featured in them. When people have to evacuate their homes in times of flood or fire, photo albums (along with pets and valuable jewelry) are inevitably the first things they grab. Here are some basic guidelines for good people pictures.

1. Photograph people in their own environments—wherever they are comfortable. Pose individuals or groups at leisure or at work and, when possible, use existing light (flash is expedient, but ordinary). If daylight or indoor light is uneven, or too dim, try slower exposures with ISO 400 or 800 film and your camera on a tripod.

2. To avoid dark shadows when you do need to use flash, add a second flash activated by a remote sensor or use a reflector. With a flash unit inserted into the camera shoe, try point-

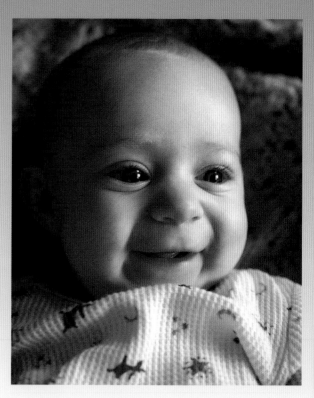

The baby was near a window—you can see its reflection in his eyes—and I focused closely with a 28–135mm lens on an SLR. If you have a close-focusing lens and your subject is appealing, remember to shoot close-up portraits, too. Professional shooters who specialize in children often have an assistant entertain small fry so they'll be distracted.

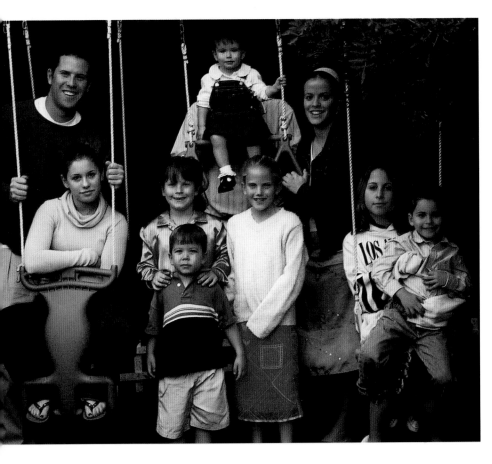

ing it up to bounce it off the ceiling and create softer light.

3. Devise your own "photo studio" at home using a variety of lights and backgrounds. Suggestions and lighting examples for this project are included below.

4. When posing people, distract them by chatting. Try a variety of poses—seated, close-ups, etc. Be a good director. Tell people how good they look even when they are between good expressions. Be sure to give prints to anyone who models for you.

The challenge of group pictures is multiplied by the number of people in the group. Someone's eyes may be closed or an expression might be off. Use small talk to distract everyone from the beginning. I want smiles—or at least cheerful expressions—for the camera. When people in a group are slightly off guard, that's when I shoot. A bright cloudy sky made posing easy for this family group.

5. As an exercise, photograph one or more individuals doing things such as cooking in the kitchen, playing a board game or doing something else they enjoy. Show parents and children having fun together. Photograph a family spending a rainy day.

> Photograph
> a family spending
> a rainy day.

6. To boost the light level in a room, replace lightbulbs in lamps with photoflood bulbs rated at 250W. Don't let them touch lamp shades because they get very hot. For more flexibility, use photofloods in reflectors or quartz lamps clamped to light stands or shelves. With photographic lights you can shoot at higher shutter speeds using ISO 400 or faster film.

7. Portrait guidelines are similar whether you shoot film or digital images. Remember that negatives and prints may also be scanned, manipulated, and printed as digital images.

● IMPROVISING A STUDIO

Appealing photographs of people can be made in an improvised studio at home. Attractive lighting, careful posing, and friendly persuasion are the keys to great images. The techniques are not difficult, and basic equipment is not very expensive. The following are some suggestions.

Backdrops

1. Choose a room at home and remove enough furniture for a shooting space at least 10' square. If the walls are not plain, hang colored or pastel fabric using duct tape. You can also adapt a garage by fastening wallboard to the walls and using thumbtacks to attach wide pieces of background fabric or paper to it.

2. At a photo or art supply store, buy a few rolls of background paper (6' or wider). Cut off enough paper to fit the space and tape it to a wall.

3. Build a sturdy frame, perhaps 5' high and 6' wide, and mount it on casters. Various background materials can then be attached to each side of the frame. (You can simply roll this unit to storage when it's not in use.)

Lights. Borrow or buy at least three photo light stands and photoflood bulb reflectors, or buy compact quartz light-

ing units that include reflectors. These are tungsten lights, also called hot lights. If your photographic space has a window, cover it when using quartz or photoflood lights with color film during the day. Attach an 80B filter over the camera lens to correct the color for negative film, or an 80A filter to correct the color for daylight slide film.

Electronic flash is also excellent for portraits because it freezes motion. One flash unit, usually attached to an SLR, could be placed on a light stand away from the camera. Test small units with a reflector umbrella and ISO 200, 400, or

This was taken in my living room with a sheet of blue paper as a background. I used two 600W quartz lights reflected from umbrellas placed fairly close on each side. My SLR on a tripod was loaded with ISO 200 Kodak Gold film. I used an 80B filter to correct 3200K light for daylight film and shot numerous poses and expressions.

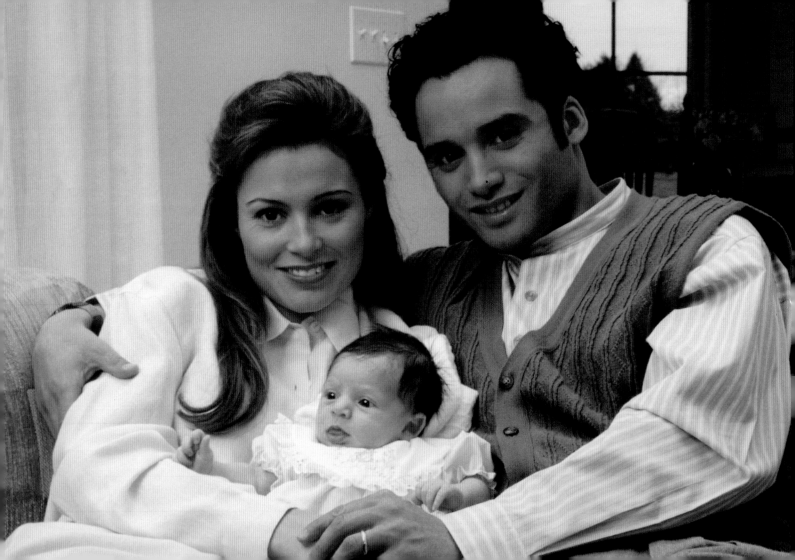

800 film. Light diffusers, such as the umbrellas or softboxes that are available for home use, offer pleasant light for portraits, but it is only half as bright as direct light. Hence, faster film speeds are suggested. Larger, more powerful AC flash units cost more than most small units or hot lights, and require a special meter for correct flash exposures.

Personally, I feel that you will learn lighting more quickly and easily using hot lights than using flash units—and you can use your camera's meter.

Tripod. For portraits, mount the camera on a tripod to ensure image sharpness at slow shutter speeds with hot lights, and so the camera stays in place while you move the lights or pose the models. A tripod that extends to 60" is fine, and some good ones even cost less than $50. Consider using a ball head on the tripod for easier camera adjustments.

Cameras and Lenses. A camera is suitable for portraits if its lens will focus to 3' or closer, and the focal length is between 75mm and 135mm to "draw" peoples' faces without distortion. SLR and point & shoot cameras with zooms are ideal. With a point & shoot camera, make hot-light exposure tests using ISO 200 or 400 film. Remember that portraits should be composed within the framing line(s) in the point & shoot finder because it doesn't see exactly what the lens sees. If you shoot with a digital camera, set it to ISO 100, 200, or faster.

● BASIC PORTRAIT LIGHTING

Begin by placing your subject on a stool (or a chair with a low back that won't show in pictures). Try ISO 200 print film and 600W hot lights, making exposures at $\frac{1}{10}$–$\frac{1}{20}$ second. To balance the film and the lights, use an 80B filter—but remember that this filter cuts the film's ISO in half, so your subject will have to be still.

In your studio setup, try some of the following lighting arrangements and create your own variations. When you use electronic flash, you can shoot spontaneous expressions and use a softbox for diffusion.

1. In portrait photography, the light that creates the highlights on the subject's face is called the main light. If you use only one light for your portraits, this is the main light. Because the shadows created by this light can be dark and unflattering, a second light is often used to brighten the shadows.

This second light is called the fill light and is placed to produce less light than the main light. I prefer to use modified light (36" white umbrellas) for both the main and the fill lights. For comparison, try two direct lights—which will be somewhat more harsh than reflected light.

2. Try shooting several portrait variations with one light placed in different positions—slightly above the model's face, directly in front, to one side, etc.

3. To improve pictures, place a light (even a bare 100W bulb in a socket) behind the model to brighten the background.

4. For a good basic setup, direct a main light from the front or from one side. Place it higher than the model's head—as high as you wish. Place a fill light to brighten the shadow areas, or use a reflector to bounce light from the main light onto the subject's face. Shoot different poses with the light sources in varying positions.

5. A highlight at one side can add a bright accent to the model's hair. Ask your supplier about a light-weight boom that extends the hairlight out from the stand.

6. Shoot lots of variations of poses. Vary the camera and light positions and study new effects as you shoot. You are in charge of these exercises, so be resourceful and enjoy learning. Expose enough film to make everyone's efforts worthwhile.

● PEOPLE PICTURES OUTDOORS

Light. It may seem quite easy to shoot portraits or group images outdoors in daylight, but direct sun makes people squint, and shadows are often too dark. For better results, turn people away from the sun, then use flash fill to brighten their faces or ask someone to hold a reflector to bounce sunlight for the same effect. For even more beautiful pictures, pose people in the shade and use a reflector or on-camera flash to create additional soft light. Done well, this

The portraits on pages 61–62 were taken with a Canon SLR and 28–80mm lens in a home studio. **FACING PAGE LEFT**—Background paper was hung from a rack made of poles, and the exposures (reduced because of an 80B filter) ranged between ⅟₂₀ second and ⅟₃₀ second on ISO 200 print film. A quartz light was placed at 45 degrees to the right, and a light on a boom accented her hair and brightened the shadow side of her face. A 75W reflector flood was used on the background. **FACING PAGE RIGHT**—Two quartz lights reflected from umbrellas were placed in front of the subject at 45 degrees to the left and right. The hair light is slightly larger, and the lighting here is more even.

can look very professional. When hazy clouds cover the sun, the diffused light that is created is also quite flattering for portraits.

Locations. Look for good portrait settings that feature decorative foliage, attractive doorways, window frames, blue sky, or water. I also enjoy locations around abandoned homes and barns, or other derelict spots that are incongruous and unique. While outdoor locations are numerous, so are messy, distracting backgrounds. Keep pictures as simple as possible, and move people or change the camera angle to eliminate possible background distractions.

Self-Portraits. Many well-known painters and photographers have created self-portraits, so don't be afraid to use yourself as a model for conventional or offbeat pictures that can be enjoyable and rewarding. Choose a setting near a window or an outdoor spot, and decide where you'll sit or stand. Put the camera on a tripod, set the self-timer, and take your position. Have fun with unusual poses and intriguing compositions. Try not to be self-conscious—Rembrandt wasn't! Shooting with a digital camera is a real advantage because you see the results immediately and can refine the images as needed.

FACING PAGE LEFT—One 600W quartz light reflected from an umbrella was placed at the subject's right. A separate light was on the background and another on her hair. **FACING PAGE RIGHT**—Reflected quartz lights on each side were evenly distanced, and more accent light was added to her hair. Reflections in her glasses were avoided by raising the lights. An 80B filter corrected the 3200K lights for 5500K film. **RIGHT**—On a hike, my grandson and I reached a waterfall where I posed him in sunlight reflected from a huge rock. The background is busy but decorative and the reflected lighting is as smooth as in a studio. Looking for lovely light is a basic photographic urge.

Inspirations. Clip portraits from newspapers and magazines and try to duplicate them. Work with a friend, and model for each other. Try to create a still life with someone's face in it, or a close-up of a person and a pet. Frame someone behind glass splashed with raindrops. Photograph two people, one partly behind the other. Arrange a family group on a carpeted floor and photograph them from a ladder, near a window, or with artificial lights. If you can imagine a portrait effect or lighting arrangement, figure out a way to create it with your own camera.

FACING PAGE—During a visit to this young man's family in Denmark, he showed up with his pet snake, and a nearby brick wall become an agreeable background. I used a Canon Elan SLR and a 28–105mm zoom with Kodak Ektachrome 100 film, though the image could have been taken with almost any camera or film. The pale shadows indicate that the sun was diffused by thin clouds.

model releases

1. Model releases are necessary for photographs used for commercial purposes, such as advertising or promotional brochures. If you use someone's photo on T-shirts you plan to sell, get a release.
2. Photographs for purely informative or educational purposes (such as the images in books, magazines, and newspapers) do not require model releases. Images on book or magazine covers, however, are considered commercial in their usage and do require a model release.
3. Releases are not necessary for taking pictures of people on streets, in public parks, or anywhere that people gather—unless photography is forbidden in that location. However, item 1 (above) still applies.
4. The law says that releases are unnecessary for images of celebrities or politicians when they are photographed in public. This does not apply to images used for advertising, however.
5. If you plan to sell photographs through a stock photo agency, ask the people you photograph for a release if you feel the photo might be appropriate for use in advertising. Promise a small fee if a photo is used in an ad.

7. scenics and travel photography

People take more pictures while traveling than they do at most other times. For many of us, vacations are times when we can really stop, look, and shoot. Happiness means finding photo opportunities—rolling green landscapes, reflecting lakes with mountain backgrounds, lofty buildings in impressive cityscapes, seascapes with wild surf, etc. Such visions glide through our minds to inspire the photo urge. This chapter contains tips to help you make the most of your scenic and travel photography.

○ TRAVEL LIGHTLY

Essential Equipment. Even if you have only one camera with a zoom lens and built-in flash, you should be equipped to shoot "Kodak moments." If yours is an SLR camera with several lenses and a separate flash, you are better prepared. Consider your equipment sensibly and try to travel lightly. Being weighed down discourages creativity.

Camera Bags. I have three shoulder bags and select one based on what I need to carry. One holds an SLR camera with one 28–135mm zoom lens, a flash unit, film, and a few filters. In the mid-size bag, I can carry an SLR body and two zoom lenses, plus accessories. In the largest bag, I can put two camera bodies, three lenses, a flash, and accessories. This bag is mainly a parking place for equipment, and I don't carry it often. All of my bags have hand grips on top and all fit under the seat of an airliner. None of the bags cost more than $65.

Tripod. A four-pound Bogen tripod also goes with me on trips, along with a slim monopod (a one-legged camera support). For vacations or weekend trips, a well-made three- to five-pound tripod is quite adequate.

FACING PAGE—The red fire boat in the harbor at Marstrand, Sweden provided interesting contrasts. My 28–105mm lens enabled me to zoom in and out of several compositions, and I chose this one for its combination of foreground red boat, middle-distance town, and background hilltop fort. PAGE 68—Colorful patterns are like magnets to photographers. These rows of flowers are being cultivated and irrigated near Lompoc, CA, where growing commercial flowers is big business. A local map showed me where flowers were concentrated, and I drove gravel roads between the colors, stopping several times to shoot exciting compositions. A two-step ladder I carry in the car gave me just enough elevation to better see and compose sections of a beautiful area.

Film. When on the road, take along the film(s) you like best. An ISO 200 or 400 type will be versatile. I use mostly ISO 100 slide film for its fine grain, but I also carry ISO 200 film for lower light levels when flash is not indicated. I'd rather use ISO 200 print film all the time because it's not as finicky about light sources or exposure as slide film is, but photo stock agencies want slides. For night shooting, all types of daylight films make nice, warm pictures. You will only need color correction filters (80A or 80B) if you want to match indoor lighting with slide or print film.

TRANSPORTATION

If you travel on a tour, you're sure to discover historic and photogenic subjects, because articulate guides can lead you to good photo spots. If you'd rather travel in your own vehicle and explore out-of-the-way locations, read the guidebooks first, research the Internet, and study maps. If plane or train travel better fits your taste, hire a taxi at your destination or rent a car. If you hike or ride a bike to find choice photographic possibilities, it can be easy to stop and shoot. You also have access to those places where cars and buses can't stop because there's no shoulder on the road. However you travel, expect to get good pictures by being observant and resourceful.

LIGHTING

Travelers are often blessed when they find or wait for early morning and late afternoon sun to shoot landscapes and city scenes. Wake up early and explore before breakfast. If you don't see what you want (and if you have time), try to envision how the late afternoon sun's warm-tinted light will make subjects appear. Turn on your imagination and come back later if you think there's pictorial promise.

Wake up early
and explore
before breakfast.

During the summer, when you arrive between 10AM and 3PM, outdoor light may not be ideal. Mountains and buildings are often flatly lit and seem featureless. Find advantageous viewpoints or return later. In the fall, winter, and spring, sunlight tends to slant photogenically toward natural and man-

made forms. Depending on the subject, midday light can be worthwhile or disappointing.

CAMERA ANGLES

The antidote for plain vanilla pictures is often a different camera position. If a scene seems ordinary, find a higher vantage point. Shadows on a high building may be somewhat interesting from eye level, but from a window on the twentieth floor of an adjoining building, there might be a much more appealing composition. Alternately, you can kneel and look up at some subjects to create more effective compositions. Because we hold 35mm cameras horizontally, many people neglect to shoot vertical images. Especially on the road, take a number of varying shots of each subject you find interesting—you may not return soon! Later, analyze which compositions you like best and why. Enjoy everything that went right.

Scenic subjects include rolling green forests, picturesque waterfalls, and eye-catching views like this one of Lisbon, Portugal, from an ancient historic hilltop. For almost an hour I varied my 28–135mm zoom lens and camera positions, framing images both horizontally and vertically.

CHALLENGING PICTURE PLACES

Not everyone gets to photograph a vast beach jammed with sea elephants in the Galapagos Islands, or visit a rainforest full of butterflies, or capture on film a group of cowboys on horseback backlit with bright dust swirling behind them. But even without these dazzling sub-

jects, you can make the most of the opportunities you have. Here are some accessible travel photography ideas:

1. County fairs, air shows, and other spectacles open to the public offer great picture possibilities.
2. Grand displays of flowers in public gardens and arboretums can be found in many communities.
3. Explore the rocks, lakes, trees, and other natural features of the state and national parks in your area.
4. Many towns, both large and small, have fascinating zoos. For instance, my wife and I have enjoyed photographing zoos in Atascadero and Santa Barbara, CA. Where are the zoos you want to visit? Take a telephoto zoom!
5. Enjoy lakes and seacoasts by twilight, as they turn purple and look magical in long exposures.

To find photogenic places, check the library or bookstores for travel guides, read the Sunday travel sections in newspapers, and read travel magazines. Explore sites on the Internet and send for literature for picture ideas.

● NIGHT PHOTOGRAPHY
Taking pictures at dusk and after dark is a treat, because the results can be unpredictable. Choose a location, mount your

RIGHT—At dusk in Moose Jaw, Saskatchewan, Canada, I spotted a small refinery not far from where we parked. Along with an SLR camera and a 28–105mm zoom lens in a shoulder bag, I carried a four-pound Bogen tripod. Several lights in the area reflected on the tanks, and as I was composing, the moon made a serendipitous appearance. I used ISO 200 Ektachrome and shot at the camera's automated three-second exposure. I focused on the refinery so the object in the foreground was out of focus. **FACING PAGE—**Slow shutter speeds create patterns unseen by the naked eye. Richard W. Sullivan shot downtown Los Angeles with his Nikon F4 on a tripod using a 16mm very wide-angle lens and exposed Kodak Ektachrome 100SW for forty seconds at f/5.6. The lens caused buildings to lean as white headlights and red tail lights streamed by.

camera on a tripod, rely on electronic exposures, and depend on serendipity. Night photography produces surprising images including colorful lights, blurred people, moving cars, and atmospheric streets. In many situations, a five- to eight-second exposure at f/8 may be indicated with ISO 100 or 200 film. The longer the shutter is open, the more blurred any moving subjects become.

One of the most photographed churches in the United States is the Mission of Saint Francis at Rancho de Taos, NM. The deep-blue sky helps set off the structures, and I framed the church through the gate from a position that emphasized the perspective. A tripod was used for precise composition and depth of field with an f/16 aperture.

When you use exposures longer than a few seconds, people and things may blur into abstraction.

Your point & shoot camera's slowest shutter speeds should be listed in the owner's manual. Some models may be limited to two or three seconds. If so, experiment with ISO 400 or faster films. Most SLR cameras can time exposures up to thirty seconds, so ISO 100 films (or faster) are okay. An added attraction: because (unlike your eyes) film collects light during long exposures, your images may show more detail in the shadow areas than was visible to you.

● EXPOSURES INDOORS IN DAYLIGHT

With ISO 200 film, the exposure inside a cathedral during the day may vary from ½ second to several seconds. When a tripod isn't permitted, brace your camera against a pillar or on the top of a pew.

Then, while holding your breath, shoot as the meter indicates. Exposures longer than one second may be slightly blurred, even when the camera is braced. So, use bracing techniques inside churches, museums, and historic homes you visit, but use a tripod whenever it is permitted. Indoor pictures are often warmly tinted due to the effect of 2900K light on daylight-balanced film. Color print processors can correct some tints, including those from fluorescents. For slides, an 80A filter corrects warm lights and an FLD filter is used for fluorescents. Digital camera pictures can be color corrected before they are printed, as can digital prints made from negatives, prints, or slides.

Scenic and travel photography is stimulating. Take great pictures and improve your photography at new places in unfamiliar lighting conditions. Compose in your mind's eye and shoot carefully, but experiment. You'll enjoy a payoff for the time and effort you invest.

Just about everything you see while on vacation is fair game for photography. These decorated children were a welcome sight on a Ferris wheel from which I was hoping to shoot the surrounding town.

8. photographing action

If your camera has fast enough shutter speeds and you have a good sense of timing and composition, shooting action should be fun. Practice photographing active children at play, batting practice, a horse jumping a hurdle, or aim at momentary facial expressions. Good action pictures can be stimulating to the ego, but timing is tricky because your shutter finger has to anticipate what's coming up in the finder.

PEAK ACTION

Peak action occurs when the child jumping rope is in midair, or when someone's smile is brightest. An outstanding example of peak action is Lydia Heston's shot made at the exact second when a jumping Maasai warrior was as high as he would go. She observed, sensed the tim-

ing sequence, and was ready. It sounds reasonably simple, but this takes practice, and disappointments in timing are inevitable until you get the hang of it.

SHUTTER SPEED REQUIREMENTS

Slow action, such as people talking, can be caught sharply at $\frac{1}{60}$ second, but $\frac{1}{125}$ or $\frac{1}{180}$ are safer. As the pace of action increases, also shoot at $\frac{1}{250}$ and $\frac{1}{500}$ second. In bright sun, I can photograph a

Lydia Heston photographed a Maasai warrior jumping as part of a dance to celebrate the hunt of the Black-Maned Lion of the Mara in Kenya. She watched a few jumps through the finder of her SLR then shot a number of frames on film, which she later scanned and printed. Lydia has refined her action timing through much experience.

To catch someone in a midair leap, practice shooting it at different shutter speeds. This isn't completely sharp at $\frac{1}{250}$ second, but a small amount of blur suggests movement.

youngster skateboarding at $\frac{1}{250}$ second and catch him in midair with no blur. I use that speed with ISO 100 slide film. With ISO 200 film, in bright sun, I can comfortably shoot at $\frac{1}{500}$ second.

On SLRs and digital cameras, the shutter speed is selected via on-screen menus or dials on the camera body. For point & shoot cameras, check the instruction booklet. You should find an indication of the maximum shutter speed, usually in the $\frac{1}{250}$ second to $\frac{1}{1000}$ second range.

Depth of Field. As the shutter speed gets shorter, your f-stop will have to become larger for proper exposure. As

a result, your depth of field will decrease. That can be an advantage when you want an out-of-focus background to contrast with a sharp main subject.

LEFT—Miniature waterfalls in a stream were excellent subjects for slow-exposure experiments. My SLR was on a tripod, and I shot this same composition at seven shutter speeds from $\frac{1}{125}$ second to one second (seen here). Try a similar series to become familiar with blur patterns and the shutter speeds that help create them. If waterfalls are not handy, try it with someone running in place or focus on a fountain. **FACING PAGE**—Richard Wagner is an expert at capturing animals and birds on film. This is an immature Ferruginous hawk, common to the western states. It was photographed with a Nikon 400mm f/2.8 lens and a 2X Nikon teleconverter, making the lens 900mm. The effective aperture was f/5.6, the film was Fuji Provia 100 pushed to 200, and the shutter speed was $\frac{1}{1000}$ second. The camera and tripod with a ball head were perched on a mountainside where hawks fly by frequently. Richard made a digital print from the slide.

● ACTION TESTING

To become more familiar with your camera, shoot a series of images of someone running about 12' away. (As noted below, subjects are more likely to appear blurred when they move across the film plane.) Start at $\frac{1}{60}$ second (which should be blurred), then shoot at $\frac{1}{125}$ second and faster—up to $\frac{1}{500}$ second or higher. Shoot from the same distance with the same focal-length lens and ask the person to run at the same pace each time. Write the shutter speeds on your prints as a reference. At $\frac{1}{125}$ second there may be some blur, at $\frac{1}{250}$ second there will be less, and at $\frac{1}{500}$ second there will probably be none.

● SEQUENCE PHOTOGRAPHY

In-camera motors that advance and rewind film are amazing. Even some modestly priced 35mm SLR models boast the ability to shoot two or three frames per second. More expensive mod-

LEFT—One definition of luck is when preparation meets opportunity. This certainly applied here as I watched a young lady enjoying a flock of pigeons in Venice, Italy. With a 28–105mm zoom on a SLR camera I made a series of pictures, including a few closeups of pigeons approaching her hands. When she felt the glee I was ready to shoot at $\frac{1}{250}$ second on Ektachrome slide film. **FACING PAGE**—Jack Fields made this charming picture in Samoa by panning the camera in synch with the movement of the couple and shooting at $\frac{1}{90}$ second as they were opposite the camera. The blurred background is typical of a panned exposure, and his composition was aided by yellow flowers that add a soft pictorial frame.

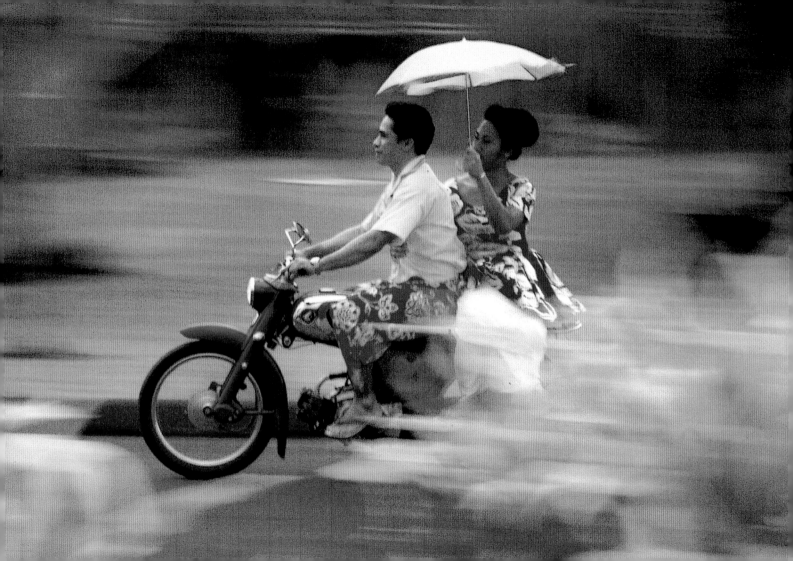

els offer more per-second photos—a feature that is extremely valuable to sports photographers. Shooting a sequence helps you catch peak action, because one of the frames in that six- or eight-frame sequence might be ideal. Shoot some test sequences. When pictures are important, shoot more than one sequence if possible.

● BLURRED SUBJECTS

The angle at which a subject moves in relation to the camera affects picture sharpness. The more distance the subject moves across the film plane, the greater the chance for blur. Try the following experimental pictures:

Subject Crossing the Film Plane (Parallel to the Camera). Choose a setting where someone can run freely and shoot at $\frac{1}{30}$, $\frac{1}{60}$, $\frac{1}{125}$, $\frac{1}{250}$, and $\frac{1}{500}$ second. Expose when the running figure is approximately opposite you. Use a tripod to concentrate fully on the subject in motion. If your camera shoots multiple frames per second, try sequences, too.

Subject Approaching at a 45-Degree Angle. Photograph a running figure advancing at a 45-degree angle, using the same shutter speeds suggested above. Shoot when the runner is close but before his head or feet are cropped off. Repeat once or twice for the experience, and try a fast sequence if your camera offers it.

Subject Approaching the Camera Head-On. Shoot when the person is framed to suit you. Use the same shutter speeds as noted in the example above.

Comparisons. The most blurred results occur when the subject runs across the scene, because the distance covered is greater during exposure than at the other angles. Running at a 45-degree angle could result in some blur at $\frac{1}{125}$ second. Minimum blur should occur with the runner coming directly at the camera. If you've seen pictures of a locomotive coming directly at the photographer, it could be moving at 20mph and still look like it's standing still in an exposure of $\frac{1}{180}$ or $\frac{1}{250}$ second. These

If your camera shoots multiple frames per second, try sequences, too.

comparison tests help you expose action situations, either sharply or with action-revealing blur. Slow shutter speeds, like $\frac{1}{30}$ and $\frac{1}{60}$ second, show blur you may sometimes want for effect.

● PANNING

Panning means synchronizing the motion of your camera with the movement of a subject across the film plane.

The couple in this action picture doesn't look like they were moving when they approached me almost head-on, but their faces tell the story. I handheld an SLR with a 70–200mm lens set at 200mm. I could have shot closer with a 300mm lens, but I didn't have one then.

Start shooting before the subject is opposite you, and continue shooting as the subject passes. Use a shutter speed such as $\frac{1}{60}$ second to stop the passing action but blur the background (the point of panning). Note the effect in Jack Fields's picture of a couple on a motorcycle (page 81). The yellow bottom corners are blurred foreground flowers. Smooth panning takes practice.

● INTENTIONAL BLUR

Intentional blur happens when you use a slow shutter speed, such as $\frac{1}{30}$ or $\frac{1}{20}$ second or slower, to photograph action. Use a tripod so that moving subjects blur while static subjects remain sharp. As an exercise, with the camera on a tripod, aim toward a street and expose passing cars at $\frac{1}{2}$, $\frac{1}{4}$, $\frac{1}{8}$, $\frac{1}{15}$, and $\frac{1}{30}$ second. If you are using a digital camera, you can see the effect immediately.

● FLASH STOPS ACTION

When a subject is within your camera's flash range (see your owner's manual for flash distance limits), subject movement will be frozen because the average flash fires at $\frac{1}{1000}$ second. As noted in chapter 5, on-camera flash does not usually yield artistic lighting, but it is really expedient—especially to catch people in

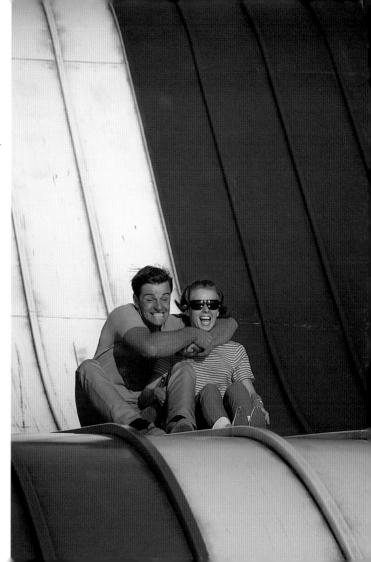

motion and capture fleeting facial expressions.

Keep in mind that some in-camera flash units do not fire the very instant you press the shutter release. This slight delay is prevalent in point & shoot cameras (both film and digital), but much less so in SLRs. As a result, you may miss some peak action situations. To compensate, anticipate pictorial action and press the shutter release a moment before peak action. If you're not sure about your flash unit, make some tests. Ask someone to laugh or move his/her hands as you shoot. In the prints you'll see how quickly your flash caught the action.

Another way to exploit action is to zoom the lens during the exposure, a technique shown in chapter 10.

edit ruthlessly

I once asked now-deceased photographer Art Kane how he maintained a consistent high standard of image quality. His response was, "Edit ruthlessly. We all shoot duds, and the trick is to recognize the ones with disappointing composition, focus, timing or with a messy background, and toss them. At least don't show them, because duds dilute the impact of your really good images." To improve your photographic batting average, be there when the light is lovely, take care composing, move closer, or do whatever it takes to make winning shots. Don't kid yourself that all your images will be satisfying just because the situation seems photogenic.

Though most types of close-up and pattern subjects are appealing because they are decorative, I also enjoy shooting subjects like rock patterns or junked cars. Whether you photograph for fun or with a specific goal in mind, close-up techniques can be rewarding.

○ CLOSE-UPS

Close, closer, closest. Most cameras and lenses can focus to about 3', which is reasonably close. When a lens can focus to about 2', that's closer. Many SLR lenses will focus as close as 15"–18". A macro lens is designed to focus even closer—it can produce life-size images on film. If you don't have a macro lens, you can fit your regular lenses with close-up lenses that screw onto an SLR lens like filters. A macro lens makes sharper images, but screw-on lenses, sold in sets of three that can be used singly or together, do quite well for about $75–100.

John Isaac, a United Nations photographer for twenty-five years, now specializes in fine-art photographs. He used an SLR and macro lens to capture the photogenic visit of a butterfly to a sunflower. He approached slowly and was able to take three frames handheld because he had no time to set up a tripod. John scanned a slide to print this beautiful image.

Depth of Field. *Depth of field decreases as you focus closer to a subject.* That means if you photograph a flower 15" from the lens at f/8, the background leaves may not be sharp until you set the focus at an aperture such as f/16. With an SLR film or digital camera, you can choose the f-stop and shutter speed combination you want to control depth of field.

Shutter Speed. To create careful close-up compositions, a tripod is essential because you often need to use slow shutter speeds in order to compensate for

Most point & shoot and SLR cameras focus closely enough for a portrait such as this, taken at a county fair. I focused on the hand, and the boy's face was in focus at f/11. The shutter speed was 1/125 second, and I used a Canon 28–135mm IS (image stabilization) lens.

the small apertures required to create good depth of field.

Film. In bright light or shade, films rated ISO 100, 200, or 400 are all okay. The faster the film, the greater the options you'll have for controlling depth of field by using smaller apertures. In most situations, ISO 200 films are a comfortable compromise.

Camera. Point & shoot cameras have limited close-up capabilities because you can't adjust their focus or exposure. The instruction booklet for a point & shoot camera should tell you how closely the lens will focus. When you know, practice doing close-ups. View your composition at several zoom-lens focal lengths, and use a tripod so it's easy to measure the distance from the lens to the subject. When you try to shoot closer than the lens is designed to do, the shutter release may not work until you back off a little. That's a good

feature to help you avoid out-of-focus pictures.

In point & shoot cameras, you do not view your images through the lens but through a separate finder. Because the finder and the lens are in different positions, they have slightly different perspectives on the same subject. Working at less than 3'–4', this can cause framing problems. In the finder of most point & shoot cameras, therefore, you'll see framing lines that indicate where you should place the top of your subject in the viewfinder when working at close distances. This ensures that the lens will see the subject the way you intend and that the subject won't be cut off in the exposed frame. Read the instructions and practice. Composing close-up pictures can become a welcome challenge. A digital finder is useful for this.

An SLR, be it film or digital, is a natural for close-ups. Because you preview

This still life by Kathleen Jacobs is part of artist Howard Finster's handiwork in Alabama. He imbedded decorative objects in cement to create a three-dimensional wall mural. Kathleen (my wife) was challenged to find a composition that typified the artist's work and would be an appealing picture as well. She made shots with a Canon point & shoot camera and a 38–135mm lens on ISO 200 negative film.

your image through the lens itself, what you see in the finder is what you get on film. You can focus selectively, and many cameras include a depth-of-field preview that allows you to see approximately where sharp focus starts and ends.

RIGHT—During a European vacation, Steve Maloney and his wife Yvette always look for pictures like this lovely pattern of fancy food in Nice, France. Both the Maloneys are artists and Steve found the colors and shapes in this arrangement irresistible. He shot on color negative film with a Nikon SLR and 28–105mm lens. **FACING PAGE**—Dick and Lynne Zinsley spotted this lilac-breasted roller on a tour of Botswana. They told me, "Our Land Rover slowed to a stop without startling this artist's palette of a bird. We used a Nikon 200mm telephoto lens that turned the anonymous soft-focused background into velvet. The click of the camera shutter sent the bird on his way."

Digital cameras offer an advantage for shooting close-ups because the sharpness of the subject and background can be viewed in the monitor immediately after exposure.

Macro Lenses. Macro close-up lenses are made in focal lengths such as 50mm, 60mm, 90mm, and 100mm. The shorter the focal length, the closer

you must be to the subject. When the subject is small, such as a watch, a closer working distance can make it tricky to place lights without the lens or camera being in the way.

● PATTERNS

There are patterns everywhere, natural and man-made, and they create excellent opportunities to compose eye-catching images. Among potential pattern subjects, look for rows of flowers, bottles on a shelf, displays of fruit and vegetables, shoes in a row, people marching, and the irregular pattern of junked cars in a lot. In my collection, I have dramatic patterns of volcanic rocks, several of weathered boards on the side of a barn, and a fine assortment of junked vehicles at an Indiana lot. More pattern and close-up ideas are included in the picture captions in this chapter. Explore your environment on walking trips or vacations and keep your eyes open for appealing patterns.

FACING PAGE—While on a walk in Venice, Italy, just as the sun was rising, book designer Kathy Jaeger recognized the dynamics of this pattern of tables and chairs. She found a chair to stand on and composed carefully, almost symmetrically. When you first look at the fascinating arrangement, it almost becomes an abstract design. Kathy shot with an SLR with the lens stopped down to f/16 for good depth of field.

10. *innovative photography*

In the first years of the 20th century, Picasso drew and painted realistically. Later, he began redesigning reality—first in the Cubist manner, and then in his own style, which has been widely copied. Piet Mondrian painted realistic landscapes until he discovered the power of simplified colorful geometric forms. Edward Weston had a portrait photography studio in a suburb of Los Angeles before he turned to visual poetry in nature. My point is that many artists created conventional images before delving into the innovative approaches that made them famous.

Photography offers wonderful opportunities as an avocation and profession, and your imagination is a launching pad for creative experiments. These can be an addition to your usual approaches to composition, subject matter, camera techniques, or lighting. If you already use Adobe® Photoshop® to manipulate images, you're beyond many of us who may try it eventually. Meanwhile, innovative, offbeat, and daring images are available with or without computer programs, and some of these are shown in this chapter.

o SELF-ASSIGNMENTS

Mark Bolster made *Justin—The Mountain Man* (facing page) for his portfolio. The location was a park bike path where he combined a motor-driven Canon EOS-1n SLR and 20mm wide-angle lens with a Vivitar flash and a Pocket Wizard radio remote unit. These items were mounted to a Bogen Magic Arm and Super Clamp attached to the right front fork of the bike. He composed to get most of the model and managed to hide the clamp. Exposure was determined by the flash output at f/8. To create

A remarkable combination of imagination and preparation paid off.

enough blur the shutter speed was ½ second. Though it looks like the man is really speeding, he was actually coasting slowly. Mark ran backwards with the remote camera control, shooting when he felt the background looked right. He exposed about four rolls of Fujichrome Velvia, and bracketed the shutter speeds. A remarkable combination of imagination and preparation paid off.

◉ FRAMING

In the photograph to the left, a view of the Duomo in Florence, Italy, created by Ghada A. Ghantous, exemplifies an artistic way of seeing. Would you have taken the picture despite the column and wire network? Ghada made these part of a pictorial frame to view the famous cathedral. Her interpretation of the scene, shot from inside an adjacent bell tower, is creative—including decorative holes at the bottom.

◉ DOUBLE EXPOSURES

Intentional double exposures (right) can be intriguing—but only when they're not an annoying jumble.

The difference depends on how well you combine two images in your mind's eye before you position them together on film. Subjects you shoot are usually fairly near each other because until you expose the second one, further photography is curtailed. Using the multiple-

exposure capability of an SLR camera, double the ISO number to ensure a correct exposure. After you make the first shot, imagine how the second one might be integrated. Try several combinations. I shot the hanging rubber gloves and then the bougainvillea, not sure how the flowers would be seen through the gloves.

○ A SLIDE SANDWICH

A more predictable way to mingle images is to sandwich two slides. Shoot an array of individual subjects and overexpose each by about a half stop. When the film is processed, look for pairs until you have some you like together. Remove the film from the mounts and place pairs together in a new mount, creating a composite image that is perhaps mysterious or even incongruously harmonious. Overexposing the film makes each slide more transparent so the com-

bination isn't too dark. Film images can also be digitized into one photo.

○ MOOD

Cheryl Himmelstein took the photo on the previous page in New Orleans at dusk. She is a professional photographer who likes using a 4"x5" view camera with color transparency film. At day's end, the man in the window posed for a one-second exposure on Fuji Astia 160 film. Existing light gave the scene a fine sense of mood and authenticity that you can find with your own camera on a tripod.

○ EXPOSURE-WHILE-ZOOMING

Exposure-while-zooming is an offbeat camera technique, the results of which depend on serendipity. It works best at night using a camera that includes automatic exposures from about eight to twelve seconds. Colorful lights and

forms are recommended subjects. Handhold the camera (facing page) or shoot from a tripod (above), and start

with a shutter speed of six to eight seconds. As the exposure begins, slowly and steadily zoom the lens to a longer or shorter focal length. Try to synchronize the zoom interval to the exposure time. If you hesitate before starting to zoom, or you don't hold the camera steadily, it doesn't matter. Wiggles in the zoom pattern are often welcome.

● SCANNING

The image to the right looks like a photograph, but it was not made in a camera. It's a fascinating demonstration of artistic skill combined with modern technology. Photographer Gene Trindl placed a rose (petals facing down) on his scanner and covered the flower with a black cloth to contain the light. The rose is composed so beautifully that it looks like a painting by Georgia O'Keefe. Try scanning flowers of your choice.

11. *pictures to remember*

This chapter is dessert. The pictures were chosen for their strong appeal, to encourage you to dream up picture projects of your own. Books and articles about photography are necessary learning tools, but personal experience with composition, lighting, and other topics is stimulating fun. In other words, photography is good for your mental health. Keep looking for images worth hanging on the walls or giving as one-of-a-kind gifts. Join a camera club, talk photography, and generate new ideas. If photography is already your creative hobby, you are doubly blessed.

NEXT PAGE—At first glance, this intriguing picture by Ghada A. Ghantous is a mystery—until you realize it was taken from a hot-air balloon and you're looking down at another balloon floating over a golf course in Southern California. End-of-the-day low sun adds to the pictorial quality. Ghada enjoyed silent ballooning and made numerous striking shots on color negative film with her Minolta point & shoot camera.

PREVIOUS PAGE—Each time I've helped judge a photo contest, I was told so many sunrise and sunset pictures are usually entered that strong competition is generated. I feel that J. Brian Menin's sunset is special, and would easily impress judges. Brian is a retired engineer for whom photography is a satisfying hobby. He shoots with an SLR and color negative film. How do your sunset or sunrise photographs compare to Brian's? RIGHT—Lydia Heston titled this emotional portrait *Comfort from a Friend*. It was taken in Bangladesh while her husband, Charleton Heston, was making a movie for a charitable organization. Notice how anonymously out of focus the background became when Lydia used an SLR with a 135mm lens on a cloudy day. FACING PAGE—John Isaac, who made this splendid photograph in India, traveled widely as a United Nations photographer. He has a fine talent for simple, graphic subjects with brilliant colors seen in reflected daylight. John digitized a color slide to make an un-cropped print for our enjoyment. Another of his outstanding pictures appears in chapter 9.

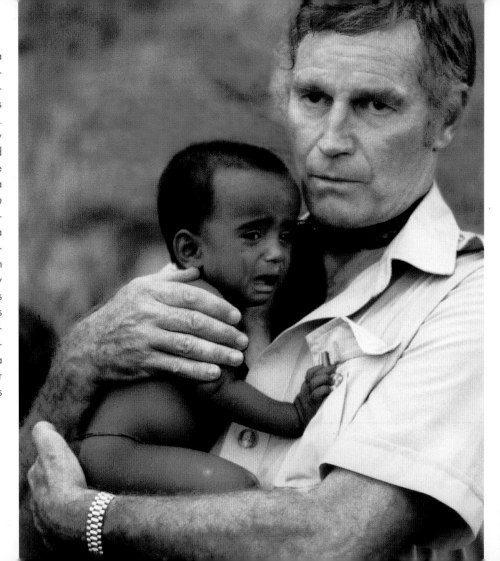

Caverns and caves with paths and lighting make unusual and mysterious photo subjects. You'll need exposures of one second or longer, so mount your camera on a tripod and shoot quickly enough to keep up with your tour group. Warm tungsten light adds color to weird formations in the Lewis and Clark Caverns in Montana. My camera was a Canon Elan SLR with a 21–35mm Sigma lens. I used no filter with ISO 100 Ektachrome film.

index

Other Books from
Amherst Media®

Photographer's Lighting Handbook
Lou Jacobs Jr.

Think you need a room full of expensive lighting equipment to get great shots? Think again. This book explains how light affects every subject you shoot and how, with a few simple techniques, you can produce the images you desire. $29.95 list, 8½x11, 128p, 130 full-color photos, order no. 1737.

Build Your Own Home Darkroom
Lista Duren & Will McDonald

This classic book teaches you how to build a high quality, inexpensive darkroom in your basement, spare room, or almost anywhere. Includes valuable information on: darkroom design, woodworking, tools, and more! $17.95 list, 8½x11, 160p, 50 photos, many illustrations, order no. 1092.

Basic 35mm Photo Guide,
5th Edition
Craig Alesse

Great for beginning photographers! Designed to teach 35mm basics step-by-step—completely illustrated. Features the latest cameras. Includes: 35mm automatic, semi-automatic cameras, camera handling, f-stops, shutter speeds, and more! $12.95 list, 9x8, 112p, 178 photos, order no. 1051.

Into Your Darkroom Step by Step
Dennis P. Curtin

This is the ideal beginning darkroom guide. Easy to follow and fully illustrated each step of the way. Includes information on: the equipment you'll need, setup, making proof sheets and much more! $17.95 list, 8½x11, 90p, hundreds of photos, order no. 1093.

Lighting for People Photography, *2nd Edition*

Stephen Crain

The up-to-date guide to lighting for portraiture. Includes: setups, equipment information, strobe and natural lighting, and much more! Features diagrams, illustrations, and exercises for practicing the techniques discussed in each chapter. $29.95 list, 8½x11, 120p, 80 b&w and color photos, glossary, index, order no. 1296.

Outdoor and Location Portrait Photography
2nd Edition
Jeff Smith

Learn how to work with natural light, select locations, and make clients look their best. Step-by-step discussions and helpful illustrations teach you the techniques you need to shoot outdoor portraits like a pro! $29.95 list, 8½x11, 128p, 60+ full-color photos, index, order no. 1632.

Make Money with Your Camera
David Neil Arndt

Learn everything you need to know in order to make money in photography! David Arndt shows how to take highly marketable pictures, then promote, price and sell them. Includes all major fields of photography. $29.95 list, 8½x11, 120p, 100 b&w photos, index, order no. 1639.

Handcoloring Photographs Step by Step

Sandra Laird & Carey Chambers

Learn to handcolor photographs step-by-step with the new standard in handcoloring reference books. Covers a variety of coloring media and techniques with plenty of colorful photographic examples. $29.95 list, 8½x11, 112p, 100+ color and b&w photos, order no. 1543.

Special Effects Photography Handbook

Elinor Stecker-Orel

Create magic on film with special effects! Little or no additional equipment required, use things you probably have around the house. Step-by-step instructions guide you through each effect. $29.95 list, 8½x11, 112p, 80+ color and b&w photos, index, glossary, order no. 1614.

The Beginner's Guide to Pinhole Photography
Jim Shull

Take pictures with a camera you make from stuff you have around the house. Develop and print the results at home! Pinhole photography is fun, inexpensive, educational and challenging. $17.95 list, 8½x11, 80p, 55 photos, charts & diagrams, order no. 1578.

Family Portrait Photography

Helen Boursier

Learn from professionals how to operate a successful portrait studio. Includes: marketing family portraits, advertising, working with clients, posing, lighting, and selection of equipment. Includes images from a variety of top portrait shooters. $29.95 list, 8½x11, 120p, 123 photos, index, order no. 1629.

Black & White Photography for 35mm

Richard Mizdal

A guide to shooting and darkroom techniques! Perfect for beginning or intermediate photographers who want to improve their skills. Features helpful illustrations and exercises to make every concept clear and easy to follow. $29.95 list, 8½x11, 128p, 100+ b&w photos, order no. 1670.

Composition Techniques from a Master Photographer

Ernst Wildi

Composition can make the difference between dull and dazzling. Ernst Wildi teaches you his techniques for evaluating subjects and composing powerful images in this beautiful full-color book. $29.95 list, 8½x11, 128p, 100+ full-color photos, order no. 1685.

Basic Digital Photography

Ron Eggers

Step-by-step text and clear explanations teach you how to select and use all types of digital cameras. Learn all the basics with no-nonsense, easy to follow text designed to bring even true novices up to speed quickly and easily. $17.95 list, 8½x11, 80p, 40 b&w photos, order no. 1701.

Picture-Taking for Moms & Dads

Ron Nichols

Anyone can push a button and take a picture. It takes more to create a portrait that will be treasured for years to come. With this book, moms and dads will learn how to achieve great results—with any camera! $12.95 list, 6x9, 80p, 50 photos, order no. 1717.

How to Take Great Pet Pictures

Ron Nichols

From selecting film and equipment to delving into animal behavior, Nichols teaches all that beginners need to know to take well-composed, well-exposed photos of these "family members" that will be cherished for years. $14.95 list, 6x9, 80p, 40 full-color photos, order no. 1729.

Beginner's Guide to Adobe® Photoshop®

Michelle·Perkins

Learn the skills you need to effectively make your images look their best, create original artwork or add unique effects to almost any image. All topics are presented in short, easy-to-digest sections that will boost confidence and ensure outstanding images. $29.95 list, 8½x11, 128p, 150 full-color photos, order no. 1732.

Beginner's Guide to Nature Photography

Cub Kahn

Whether you prefer a walk through a neighborhood park or a hike through the wilderness, the beauty of nature is ever present. Learn to create images that capture the scene as you remember it with the simple techniques found in this book. $14.95 list, 6x9, 96p, 70 full-color photos, order no. 1745.

Beginner's Guide to Digital Imaging

Rob Sheppard

Learn how to select and use digital technologies that will lend excitement and provide increased control over your images—whether you prefer digital capture or film photography. $29.95 list, 8½x11, 128p, 80 full-color photos, order no. 1738.